GU00362604

40 DIGITAL PHOT RETOUCHING

TECHNIQUES

Copyright © 2005 Youngjin.com Inc., 1623-10 Seocho-dong, Seocho-gu, Seoul 137-878, Korea. World rights reserved. No part of this publication may be stored in a retrieval system, transmitted, or reproduced in any way, including but not limited to photocopy, photograph, magnetic, or other record, without the prior agreement and written permission of the publisher.

ISBN: 89-314-3512-6

Printed and bound in the Republic of Korea.

How to contact us

E-mail support@youngjin.com feedback@youngjin.com.sg

Telephone: +65-6327-1161

Fax: +65-6327-1151

Manager: Suzie Lee

Chief Editor: Angelica Lim

Acquisitions and Developmental Editor: Mariann Barsolo Production Editor: Dennis Fitzgerald, Patrick Cunningham

Copyeditor: Nancy Riddiough Book Designer: Litmus

Cover Designer: Litmus
Production Control: Ann Lee

The aim of this book (and the others in the Go Digital series) is to show you how to use a simple tool to produce professional work that you can be proud of, whether you are a commercial photographer or hobbyist. Although you may master Photoshop Elements by the end of this book, the focus here is on producing sophisticated-looking results in as short a time as possible.

On the other hand, this book may be results-oriented, but it is not short on good pedagogy. If you have no prior knowledge of any image-editing software, a good way to approach this book is to read the Introduction, which contains all of the background information and basic skills you need to try out the techniques.

If you have some experience with an image-editing program, you can pick any of the 40 techniques and blast off to the planet of professional-looking images right away. All of the examples used in this book are carefully selected for their educational value, industry relevance, and artistic quality. With the release of Photoshop Elements 3.0, our instruction and exercises have been reviewed, updated, or replaced to ensure that you explore the outer limits of what Photoshop Elements 3.0 can do. The new workspace is covered in full, and you'll be swimming along with version 3.0 in no time.

Anyway, enough said. Let's have fun!

Introduction Warming Up to Photoshop Elements 7					
Key Features					
	Understanding Pixels and Resolution				
	Understanding Image File Formats				
	Tour	ing the Welcome Screen	17		
	A Closer Look at the Photoshop Elements 3.0 Editor Window				
	Esse	ntial Photoshop Elements Know-How	24		
		Opening an Image File	24		
		A Closer Look at the Organizer Window	27		
		Saving an Image File	29		
		A Closer Look at the Save As Dialog Box	30		
		A Closer Look at the Save for Web Dialog Box	31		
		Changing the View	32		
Chapter 1 Correcting Contrast 33					
	1	Diagnosing the Problem	38		
	2	Correcting Blurred Images	40		
	3	How the Pros Do It	42		
	A Clo	oser Look at the Levels Dialog Box	44		
	4	Correcting Backlighting	45		
	5	Brightening a Specific Spot	48		
Chapter 2 Manipulating Colors 51					
	6	Changing a Color	52		
	A Clo	oser Look at the Hue/Saturation Dialog Box	54		
	7	Replacing a Color	55		
	8	Desaturating Part of An Image	57		
	9	Turning Color Photos into Black-and-White Images	61		
	10	Coloring Black-and-White Photographs	64		
	11	Creating a Sepia-Toned Picture	71		
	Blending Colors				
	12	Turning Summer into Fall	74		
	13	Making Detailed Color Changes	78		
	A Clo	ser Look at the Color Replacement Tool Options Bar	81		

Chapter 3 Enhancing Portraits 83					
Ch		r 3 Enhancing Portraits			
	14	Removing Red Eyes	84		
	15	Removing Facial Blemishes	86		
	16	Applying Makeup	93		
	17	Creating Bigger Eyes and a Sharper Chin	99		
	18	Emphasizing a Subject	104		
	19	Opening Closed Eyes	108		
	20	Selective Focusing	112		
	21	Creating a Studio Background and Picture Package	116		
	22	Adding a Picture Frame	126		
Chapter 4 Editing Skills and Special Effects 131					
	23	Automatically Separate Scanned Images	132		
	24	Opening and Processing a Camera Raw Image File	133		
	25	Adjusting Image Size and Shape	136		
	26	Cleaning Up Backgrounds	145		
		g the Shift Key for Straight Lines	148		
	27	Creating Reflections	149		
	28	Adding Type Effects	152		
	29	Altering Perspective	154		
	30	Combining Images	157		
	31	Combining Product Pictures	161		
	01	Combining Freddict Fields			
Chapter 5 Very Special Effects 167					
	32	Stitching Panoramas	168		
	33	Adding Motion Blur	171		
	34	Giving Photos an Antiqued Look	173		
	35	Maintaining Texture While Repainting an Object	176		
	36	Let It Snow	181		
Chapter 6 Using and Sharing Images 185					
	37	Making a Postcard	186		
	38	Making a Slide Show	192		
	39	Making a Web Banner	201		
	40	Making a Web Photo Gallery	206		
	Con	tents of the Supplementary CD	210		
	Inde	x	211		

]...

40 Digital Photo Retouching Techniques

Warming Up to Photoshop Elements

Photoshop Elements is an easy-to-use image-editing program designed specifically for novice users and amateur photographers. It comes with all the basic features of Photoshop, a popular graphics program used by commercial artists and designers, but at only a fraction of the cost. Compared to Photoshop, Photoshop Elements has a significantly simpler editing process; its novice-friendly interface allows you to quickly and effortlessly correct, enhance, and retouch images.

In this book, you will learn how to edit and work creatively with your images in Photoshop Elements. From Chapter 1 onward, you will explore 40 real-life techniques listed in order of difficulty and grouped thematically. But before you jump into editing mode, it is a good idea to read this chapter for an introduction to the key features of Photoshop Elements and for some background knowledge about computer graphics editing.

Key Features

Cocus on image retouching

Photoshop Elements may be a cut-down version of Photoshop, but the user experience is completely different. The most obvious difference is that classic Photoshop features and functions have been reorganized or tailor-made to suit photography enthusiasts. The program is great for retouching images, such as sharpening blurred pictures, correcting overexposure, and fixing red-eye. All these can be done with a few clicks of the mouse or by changing a few parameters' values.

▲ Red eyes caused by using a flash

▲ Using the Red Eye Brush Tool to fix red eyes

▲ Original image of a blue car

▲ Changing the color of the car

Creative photography

Photoshop Elements enables you to color images or enhance them by adding a picture frame, snow, or a myriad of other special effects. You can also combine several images together to create a unique mosaic.

▲ Creative image retouching using the Brush Tool

▲ Blending a picture of an artist's mannequin into the beach

▲ Original picture of the baby

▲ Adding a picture frame and text effects

Sability

If you are an avid photographer, you know that locating an image from the hundreds or thousands of images in your computer is a tiresome and time consuming process. Photoshop Elements 3.0 makes finding and organizing images a less painful process with the very usable Organizer window. The Organizer lets you find images in many ways and allows you to tag and organize your files. You can also view an image's metadata.

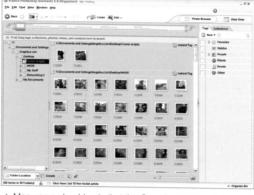

▲ Mac users should note that the Organizer window (above) is not found in the Mac version of Photoshop Elements.

Tlexibility

Photoshop Elements is a flexible program that lets you do more than retouch images. The program makes it easy for you to create slide shows, photo albums, post cards, calendars, Web photo galleries, VCDs, and DVDs using your images. A great way to explore these options is through the Welcome Screen, which lets you jump straight into the relevant window or dialog box for your project. Photoshop Elements is also flexible when it comes to printing, as it allows you to arrange several images on the same page for printing.

The Welcome Screen for Mac Users

In the Mac version of Photoshop Elements 3.0, the Welcome Screen is more basic. Mac users should note that there are no options for making postcards, slide shows, or other such creations.

▲ Most of the exercises in this book are performed in the Standard Edit workspace, To open the workspace, select Edit and Enhance Photos in the Welcome Screen,

Understanding Pixels and Resolution

What are pixels?

If you blow up a scanned image or a picture taken using a digital camera, you will see that the image is composed of small squares. These small squares are the smallest unit in an image and they are called pixels (short for picture elements). An image usually contains thousands of such pixels, each with its own color information and packed closely together. Optical illusion causes our eyes to take in the composition of pixels as a complete image. When you modify a certain area of an image, you are actually changing the pixels within that area. How well you modify these pixels will determine the quality of the final picture.

The image at its original size

▲ The more you magnify the image, the more apparent the pixels become

What is image resolution?

Image resolution refers to how compactly pixels are packed in an image. Image resolution is measured in pixels per inch (ppi). A resolution of one pixel per inch (1 ppi) means that there is one pixel in an area measuring one inch by one inch. A resolution of 10 pixels per inch (10 ppi) means that there are 10 pixels along each side of the same one-inch square. Thus, the higher the resolution, the more pixels there are in the image, and the better the quality of the image because a higher resolution allows for more details.

The relationship between image resolution and file size

The resolution of an image has a direct impact on file size. Although the image quality gets better at higher resolutions, the file size also increases.

 The file size of the image on the right, which has a resolution of 300 ppi, is 1.23 megabytes (MB).

Image size: 1,23MB ▶

 The same image at 72 ppi has a smaller file size of 73 kilobytes (KB), since the image is made up of fewer pixels.

Image size: 73KB

At 36 ppi, the file size of this image is even smaller at 18 kilobytes.

Image size: 18KB ▶

The difference between low- and high-resolution images

The image shown has an area of 3.94 inches by 2.63 inches and a resolution of 180 ppi. This means that there are 709 pixels along the width of the image and 473 pixels along the height. This works out to a total of 709×473 or 335,357 pixels for the entire image.

▲ Image resolution: 180 ppi

▲ Width: 709 pixels, Height: 473 pixels

▲ Magnifying the image

V Units of Resolution

Resolution may be measured in pixels per inch (ppi) or dots per inch (dpi). Ppi is used to refer to the number of pixels per inch in a digital image. The resolution of a scanned image, for instance, is measured in ppi. Dpi refers to the number of dots that a printer can print per inch. The resolution of a print out is measured in dpi. In Photoshop Elements, you can set the image resolution to pixels per inch or pixels per centimeters.

Using the preceding example, if you leave the image size alone and reduce the resolution to 72 ppi, there will be 284 pixels along the width and 189 pixels along the height. The image will have a total of 284×189 or 53,487 pixels.

Because you did not change the image size, there is no difference in the size of the printed image. The image, however, will be less sharp because the resolution is lower (72 ppi compared to the original 180 ppi). This image is of a lower resolution compared to the high-resolution image generated at 180 ppi.

▲ Image resolution: 72 ppi

▲ Width: 283 pixels, Height: 189 pixels

▲ Magnifying the image

Understanding Image File Formats

Photoshop Elements allows you to save image files in different formats for different purposes. Factors such as file size and quality have to be considered when choosing a file format. The following file formats are supported by Photoshop Elements:

Adobe file formats

▶ ▶ Photoshop (*.PSD, *.PDD)

These file formats are exclusive to Photoshop and Photoshop Elements. Files saved in these formats tend to be larger than other image file formats because all layer and channel information is saved. Despite a larger file size, this format is useful because it allows you to work on the file as you left it when you open it again.

▶ ▶ Photoshop PDF (*.PDF, *.PDP)

The Portable Document Format is the file format commonly used for sharing documents over the Internet due to its flexibility and widespread compatibility. Photoshop Elements recognizes the generic PDF format and also the Photoshop PDF format.

Generic PDF files, in general, are created using Adobe Acrobat. You can open generic PDFs in Photoshop Elements, but you can only save them in Photoshop PDF format. A file saved in Photoshop PDF format can only contain one page, while a generic PDF can contain multiple pages. You should also remember that when a generic PDF file is loaded into Photoshop Elements, hyperlinks and all other Adobe Acrobat attributes will be changed into images.

File formats suitable for the Web

▶ ▶ CompuServe GIF (*.GIF)

GIF, or Graphic Interchange Format, is a file format that saves images in 256 or fewer colors. Because of this, it is not suitable for most continuous-tone images but works well for images with large areas of solid colors and crisp details.

▶ ▶ JPEG (*.JPG, *.JPEG, *.JPE)

JPEG, an acronym for Joint Photographic Experts Group, is an image file format that retains all the color information of an image but reduces file size by selectively throwing away data.

JPEG is most useful for saving photographs and other continuous-tone images. Images can be compressed at different levels. A higher level of compression gives a smaller file size but also a lower image quality, while a lower level of compression results in a larger file size but a higher quality image.

▶ ▶ PNG (*.PNG)

PNG, or Portable Network Graphics, is a file format that was developed as an alternative to GIF and is intended for Web usage. Like GIF, PNG-8 supports 8-bit color depth or 256 colors and is suitable for images with few variations in color. PNG-24, on the other hand, supports 24-bit or 16,777,215 colors, which are about all our human eyes can see, so it is recommended for continuous-tone images. In addition, PNG-24 supports many levels of transparency, unlike JPEG.

Print and other file formats

▶ ▶ Photoshop EPS (*.EPS)

EPS, or Encapsulated PostScript, allows files to be shared by most graphics, illustration, and page-layout programs, such as PageMaker and QuarkXPress. EPS images are best printed on PostScript-enabled printers. Many color separators and printers accept images in this format

▶ ▶ ▶ BMP (*.BMP)

BMP, a standard image format used on Windows-compatible machines, allows you to set the color depth to control image quality and file size.

▶ ▶ ▶ PICT (*.PCT, *.PICT)

PICT, the standard image format for Macintosh environments, allows for 16-bit and 32-bit color depth settings. It is especially suitable for compressing flat-color images.

▶ ▶ ▶ PCX (*.PCX)

PCX is a bitmap file format widely supported on both Windows-compatible and Macintosh machines.

▶ ▶ TIFF (*.TIF)

TIFF, or Tagged-Image File Format, is a flexible bitmap file format supported by most graphics, illustration, and page-layout programs. It is often used for cross-platform file exchange.

▶ ▶ Pixar (*.PXR)

The PIXAR format, developed and named after the Pixar computer technology used in the making of the movie *Toy Story*, is used most frequently on PIXAR computers. It is also supported on the Macintosh.

▶ ▶ TGA (*.TGA, *VDA, *.ICB, *.VST)

TGA, or Targa, is designed for systems using the Truevision video board. It automatically creates alpha channels that include 256 or fewer shadows, and it can be easily combined with background images in Photoshop Elements or other image-editing programs.

▶ ▶ RAW (*.CRW, *.ORF, *.RAF, *.NEF, *MRW)

'Raw' is a term referring to a file that has a record of the raw, or in other words, unprocessed data captured by a camera sensor. A raw file is not a single file format. All digital camera makers use their own technology to record and save a raw format. For instance, Nikon's raw format has the .NEF file extension while Olympus uses the .ORF extension. Only mid-range and above digital cameras are capable of saving an image in a raw file format because of the large file size. With entry-level cameras, the raw data from a camera sensor is automatically processed and compressed into JPEG files, resulting in a loss of data or quality.

Touring the Welcome Screen

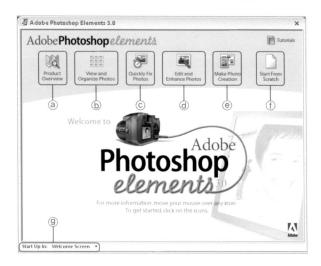

(a) Product Overview

Click on this button for an introduction to Photoshop Elements. The product information will display in the Welcome Screen itself. You can select Product Overview or Upgrading from a previous version of Photoshop Elements? in the lower-right corner of the Welcome Screen for additional information regarding these topics.

(b) View and Organize Photos

Selecting this button launches the Organizer window. The Organizer window makes it easy for you to find and organize your images. This window, which is new to Photoshop Elements 3.0, is not available in the Macintosh version of the program.

© Quickly Fix Photos

If you are looking to perform some simple editing on an image, click on the Quickly Fix Photos button to open the Quick Fix workspace in the Editor window. In the title bar, you can see the word, "Editor," which indicates that this is the Editor window. In the top-left corner, you can also see that the Quick Fix button is selected. The Quick Fix workspace lets you fix common and easily corrected problems such as those related to color and lighting.

(d) Edit and Enhance Photos

Selecting this button launches the Standard Edit workspace in the Editor window. The Standard Edit workspace is where you can access all of Photoshop Elements' editing commands, tools, and palettes. Unless otherwise stated, almost all of the exercises in this book are carried out in this workspace.

(e) Make Photo Creation

The Make Photo Creation button opens the Creation Setup dialog box, which guides you step-by-step in making creations such as postcards, slideshows, and photo albums.

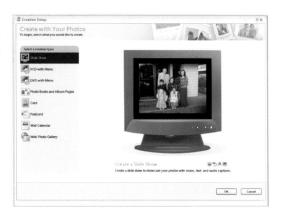

(f) Start From Scratch

Like the Edit and Enhance Photos button, the Start From Scratch button launches the Standard Edit workspace in the Editor window. The difference is that the Start From Scratch button automatically opens the New dialog box in the workspace.

9 Start Up In

If you find it a hassle to go through the Welcome Screen every time you launch Photoshop Elements, you can tell the program to launch in the Editor or Organizer window using the Start Up In menu. If you change your mind, simply select [Window]-[Welcome] to open the Welcome Screen and make a new Start Up In selection.

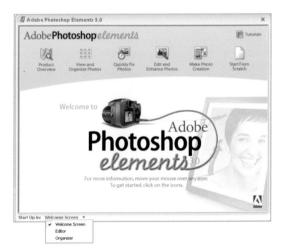

A Closer Look at the Photoshop Elements 3.0 Editor Window

The Editor Window contains two workspaces, the Quick Fix workspace and the Standard Edit workspace, and you can toggle between these two workspaces by selecting the Quick Fix or Standard Edit buttons. Since the Standard Edit workspace contains a more complete editing environment, let's take a look at the Standard Edit workspace and its various features in this section. After you get familiar with the Standard Edit workspace, you will find it easy to explore the Quick Fix workspace on your own.

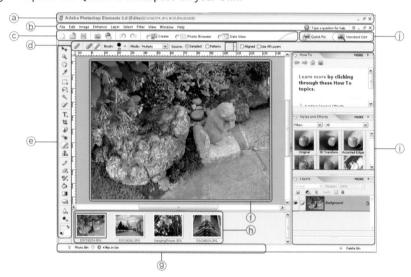

(a) Title bar

The title bar displays the name of the image file, the magnification at which the image is being viewed, and the image mode (bitmap, grayscale, indexed color, or RGB).

Adobe Photoshop Elements 3.0 (Editor) DSCN5274.JPG @ 35.8%(RGB/8)

Menu bar

The menu bar displays menus for the various commands available in Photoshop Elements. Clicking on a menu item will pull down the associated sub-menu.

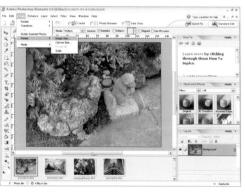

▲ Selecting [Image] from the menu bar

© Shortcuts bar

The shortcuts bar contains icons for commonly used functions, such as File, Save, and Print. The other buttons on the shortcuts bar are for opening a different workspace. The Create button opens the Creations Wizard dialog box while the Photo Browser and Date View buttons open the Organizer window.

d) Options bar

The options bar allows you to configure the options for a tool you've selected.

Toolbox

The toolbox contains all the tools you need for working on images, including selection, drawing and painting, correction, and navigation tools. Placing the cursor over a tool will reveal the tool's name and the keyboard shortcut for accessing the tool. This text is called the tool tip. At the bottom of the toolbox are two color swatches that you can use to set the foreground color (i.e., your tool color) and the background color.

A small triangle at the lower-right corner of a tool indicates that the tool has additional tools associated with it. These are called hidden tools. Clicking the right mouse button or holding a left mouse button click on a tool will reveal the hidden tools.

f Active image area

This is the area where the current active image is displayed.

Status bar

The status bar displays the status for the current image, namely the zoom ratio, the image dimensions, and information about the active tool.

(h) Photo Bin

The Photo Bin shows you a thumbnail of all the images that are opened in the Standard Edit workspace. You can click on an image's thumbnail to make the image the active file in the workspace.

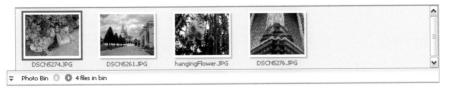

(i) Palette Bin

Photoshop Elements comes with 11 palettes, each with different functions to help you monitor and modify images. The palettes can be accessed from the Window menu. You can keep the palettes in the Palette Bin or leave them in the work area.

(j) Workspace buttons

These buttons let you switch between the Quick Fix and Standard Edit workspaces in the Editor window.

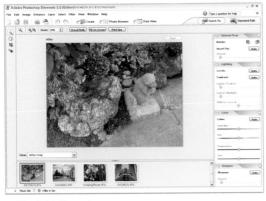

▲ The Quick Fix workspace

▲ Click on the Filters tab in the Palette Bin to view the Filters palette.

Essential Photoshop Elements Know-How

Now that you have an understanding of the Photoshop Elements interface, we will devote the rest of this introduction to learning how to perform some essential steps in the program. In the following pages, you will learn how to open and save an image file, and change the view of the image window.

Opening an Image File

There are three ways of opening an image file in Photoshop Elements:

Using the [File]-[Open] command

1 Select [File]-[Open] from the menu bar.

The Open dialog box appears.

2 Select the image file from its folder. Click Open.

The selected file will appear in the Photoshop Elements image window.

You can also open an image file using the keyboard shortcut cm+ o See the note on page 29 for information on Macintosh key commands.

Double-clicking on an empty workspace

1 Double-click on the empty workspace. This is the gray background where the image window will appear when a file is opened.

The Open dialog box appears.

2 Select the image file from its folder. Click Open.

The selected image file will appear in the Photoshop Elements image window.

Osing the photo browser

1 Click on the Photo Browser icon in the shortcuts bar.

The Photo Browser opens in a new window.

2 Select [File]-[Get Photos] and select the location where the photos can be found. For this exercise, let's select [From Files and Folders].

After you have selected the photos, you do not need to perform this step again because the photos can be found in the Photo Browser.

3 When the Get Photos From... dialog box appears, locate the image and click Get Photos or OK.

4 In the Photo Browser, you can see the image's thumbnail. Right-click on the image and select the workspace that you want to edit the image in. You can choose Auto Fix Window, Go to Quick Fix, or Go to Standard Edit.

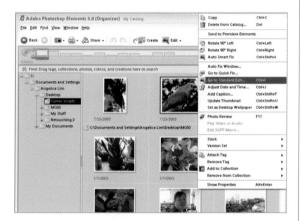

A Closer Look at the Organizer Window

The Organizer window contains the Photo Browser workspace and the Date View workspace. Because the Photo Browser workspace is more commonly used than the Date View workspace, we will only look at the Photo Browser workspace in this section. The Date View workspace looks and works like any computer calendar program so you will probably find it easy to explore the workspace on your own.

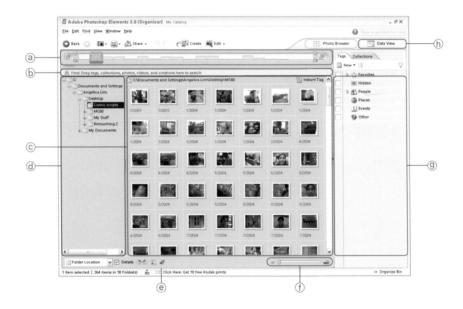

- (a) **Timeline:** A bar on the timeline indicates the volume of images taken on that day on the timeline. If you click on a bar, the main window will show you the images taken on that day.
- (b) Find bar: You can drag a tag from the Tag pane on the right to the Find bar to quickly locate the images that are tagged with the selected tag. You can also drag a photo to the bar to find similar photos, but this feature can be rather tricky to use effectively.
- © Main window: The main window contains the thumbnails of images that you have selected for review.

- @ **Sort:** The sort frame provides options such as date, batch, or location for sorting images in the main window. The purpose is to sort through the images to make it easier to find what you're looking for.
- Photo review: Click this button to view an image at full-screen. To exit photo review, click the Escape button.
- **Thumbnail size slider:** Dragging the slider's handle to the left makes the thumbnails smaller while dragging to the right makes them larger
- Tags and Collections panes: You can tag or add an image to the Tags and Collections panes to
 organize and quickly access your files.
- **(h) Date view:** The Date View workspace lets you look for images and files in a calendar format.

Saving an Image File

Osing the [File]-[Save] command

Select [File]-[Save] from the menu bar to save the image file using the same name in the current file format. If you save an image using [File]-[Save], the original image will be overwritten by the changes made.

(sing the [File]-[Save As] command

1 Select [File]-[Save As] from the menu bar.

The Save As dialog box appears.

- 2 Type in the file name and select the image format.
- (3) Click Save.

Using the [File]-[Save for Web] command

1 Select [File]-[Save for Web] from the menu bar.

The Save for Web dialog box appears.

(2) Click OK.

The Save Optimized As dialog box appears.

3 Type in the file name. Click Save.

V Keyboard Shortcuts on the Macintosh

Photoshop Elements runs on both the Windows and Macintosh operating systems. The program functions the same on both platforms, but there are a few keyboard differences. For example, the shortcut to open a file in Photoshop Elements is Ctrl+ o in Windows; it's Command + o on the Mac. Throughout this book, the keyboard shortcuts given are based on the Windows platform. Mac users should have no problem following along if they learn a few keyboard equivalents:

Windows	Macintosh	
Shift	Shift	
Alt	Option	
	Command (or "apple" key)	
right-click	Ctrl +click	

A Closer Look at the Save As Dialog Box

The Save As dialog box lets you define how an image file should be saved. Let's look at some of the options.

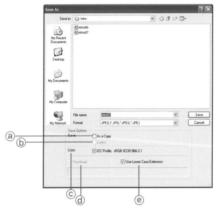

- (a) As a Copy: Check this option to save the image file as a copy, leaving the original image intact. The new file has the word "copy" in the file name.
- (b) Layers: This feature will be activated if you have used layers in the image file. Check this option to preserve the layers. If you do not check this option and save the image as an image file (whether JPEG or other file formats), the layers will be merged with the background layer.
- © Color: Check this option to save the color information of the image.
- @ Thumbnail: Check this option to create a thumbnail for the saved image file. This thumbnail will be shown in the Open dialog box when the [File]-[Open] command is selected.

Changing the Thumbnail Option

By default, the Thumbnail option is selected. To change the setting, select [Edit]-[Preferences]-[Saving Files] from the menu bar. When the Preferences dialog box appears, select an option from the Image Previews drop-down menu.

Use Lower Case Extension: Check this option to have the file format extension displayed in lower case. If not selected, the file format extension will be displayed in upper case.

A Closer Look at the Save for Web Dialog Box

The Save for Web dialog box allows you to adjust settings that determine the size and quality of images saved for the Web and to save files as GIF animations. It also lets you preview the effects of the settings you make.

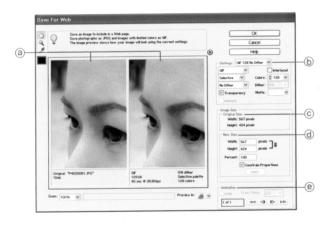

- (a) Preview window: Displays the original image on the left and the optimized image on the right.
 Also shows the file size and loading time for each image.
- (b) Settings: Displays the compression file formats and color depth options available.
- © Original Size: Displays the image size and resolution of the original image.
- @ New Size: Allows alteration of the image size and resolution.
- (e) Animation: Saves file as an animated GIF file.

Why Optimize?

A large, high-resolution image will take a long time to load on a Web page. To keep downloading speed fast, images need to be saved in one of the compression file formats and settings need to be adjusted in order to preserve the best possible quality at the smallest possible size. This process is known as optimizing an image.

Changing the View

As it is often necessary to zoom in on certain parts of an image for more detailed work. This section describes how you can use the Zoom Tool and the Hand Tool to change the view of the image.

Pooming in on a selected area

- 1 Select the Zoom Tool () from the toolbox.
- 2 Click and drag over the area you wish to magnify.

The selected area will be magnified and shown in the active image window.

The zoom ratio is shown on the title bar at the top of the window.

Cooming in on the entire image

- 1 Select the Zoom Tool () from the toolbox.
- 2 Click on the image window to magnify the entire image.

Cooming out of an Image

1 Select the Zoom Tool () from the toolbox.

2 Hold down Alt .

The mouse pointer changes to Q.

(3) Click the image to zoom out.

Press Ctrl + Spacebar to change the cursor or selected tool to the Zoom In Tool. Press Att + Spacebar to convert to the Zoom Out Tool.

Moving the magnified image

After you have zoomed in a few times on an image, you may no longer be able to see the entire image in the image window. In such cases, you must use the Hand Tool to move your view to another part of the image.

1 Select the Hand Tool () from the toolbox.

② Click and drag the tool in the image window to move the image.

Press and hold down Spacebar to the spacebar to switch from a selected tool to the Hand Tool.

Osing keyboard shortcuts

Resizes the image to fit the Photoshop Elements window so the entire image is visible.

▲ The image fits the Photoshop Elements window nicely.

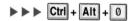

Displays the image at 100% view.

▲ The title bar shows the magnification at 100%.

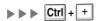

Magnifying the zoom of the image also increases the size of the image window.

▲ Holding down the Ctrl key and pressing the + one time

Reducing the zoom of the image also decreases the size of the image window.

▲ Holding down the Ctrl key and pressing - two times

Magnifying the zoom of the image does not change the size of the image window.

▲ Pressing Ctrl + Alt + + two times

Reducing the zoom of the image does not change the size of the image window.

▲ Pressing Ctrl+Alt+- two times

40 Digital Photo Retouching Techniques

Correcting Contrast

If you are a photography enthusiast, you know that light is the defining factor in photography. You probably also know that getting the perfect lighting conditions for the right exposure is sometimes out of your control. Backlit photos, for instance, are sometimes unavoidable

In this chapter, you will learn to evaluate the contrast of an image in Photoshop Elements and correct the problem like a pro. In addition, you will make an out-of-focus picture appear more focused by increasing the contrast of the image.

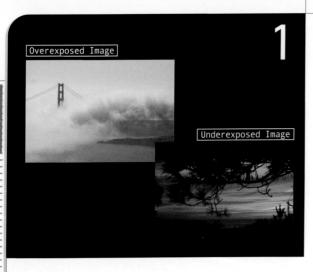

Diagnosing the Problem

One of the most common problems in taking pictures is getting the right exposure. Although you can tell just by looking whether an image is under or overexposed, you can make more accurate corrections if you use the Histogram function in Photoshop Elements.

Pbout the histogram

The histogram works by mapping the number of pixels at each tonal value. If the pixels are concentrated in the shadows, this means that the image has more dark areas. An image with pixels more or less evenly spread across the histogram would have a full tonal range. By understanding the information provided in the Histogram dialog box, you will know exactly which part of the histogram needs adjustment when correcting the image tone.

🕟 nalyzing an overexposed image

1) Select [File]-[Open] from the menu bar.

The Open dialog box appears.

Open the Sample\Chapter 1\Tech0101.tif file from the supplementary CD.

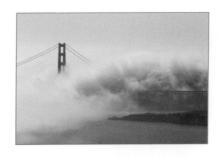

3 Select [Window]-[Histogram] from the menu bar. When the Histogram dialog box appears, check that **Luminosity** is selected under the Channel option.

Notice that the right side of the histogram is extremely high. This is an indication that the image is too bright. Such an image is known as a high-key image.

4 Click OK to close the Histogram dialog box.

You can also choose to plot the intensity of the reds, greens, and blues in the image if you are working with an RGB image.

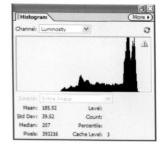

Analyzing an underexposed image

1 Select [File]-[Open] from the menu bar.

The Open dialog box appears.

Open the Sample\Chapter 1\Tech0102.tif file from the supplementary CD.

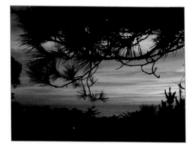

3 Select [Window]-[Histogram] from the menu bar.

The Histogram dialog box appears. In contrast to the previous histogram, the left side of this histogram is very high. This is an indication that the image is too dark. Such an image is called a low-key image.

Other than high-key and low-key images, average-key images also need to be fixed. Average-key images are those with a concentration of pixels in the middle portion of the histogram. These images tend to look dull because they are dominated by grays or midtones.

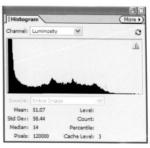

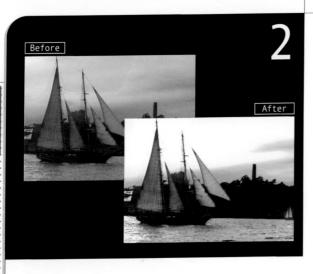

Correcting Blurred Images

If your image is slightly out of focus, you can increase the brightness and contrast to make it appear sharper. If you have a very blurred image, however, there is no way that you can make it look focused. The best thing to do is to shoot the photo again. Always remember the GIGO (pronounced gee-go) principle. GIGO is short for Garbage-In, Garbage-Out. It is a computer term to describe that the output will only be as good as the input.

Select [File]-[Open] from the menu bar.

The Open dialog box appears.

- 2) Open the Sample\Chapter 1\Tech02.tif file from the supplementary CD.
- 3 Select [Enhance]-[Adjust Lighting]-[Brightness/Contrast] from the menu bar.

The Brightness/Contrast dialog box appears.

4 Set Brightness to **20**. Click the Preview checkbox to view the effect without closing the dialog box.

Note that the image is now brighter.

Always preview the image when making changes to the contrast. This is to make sure that the colors are not compromised for the sake of sharpness.

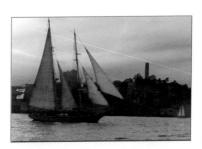

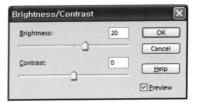

(5) Set Contrast to 40.

This makes the image look sharper.

In most cases, setting the Contrast to twice the Brightness value you just entered will produce the best results.

6 Click OK.

You can also change the brightness or contrast by using the slider bars, but typing in a value is quicker and more accurate-especially if you want to apply the same setting to a few images.

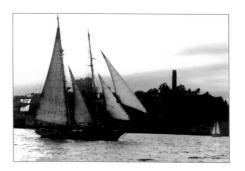

Press the Alt key to change the Cancel button to the Reset button. You can then reset the Brightness and Contrast values to 0 by clicking the Reset button.

Generally speaking, you must adjust the contrast whenever you change an image's brightness. If you brighten up an image without adjusting the contrast, its shadows will look too bright, making the image look like a faded photo.

In the example to the right, the Contrast has been increased to 80. At this high level of contrast, the image is almost turned into a black-and-white picture.

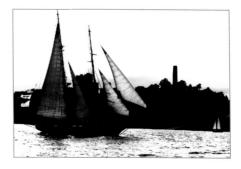

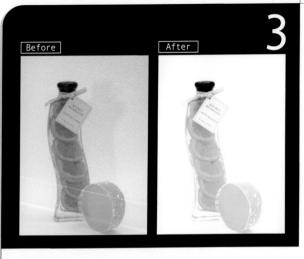

How the Pros Do It

Commercial photography usually requires sophisticated equipment that is beyond the budget of most hobbyists and amateur photographers. Using the Levels command in Photoshop Elements, you can correct and enhance product images taken using digital cameras to achieve professional-looking results.

Brightness/Contrast versus Levels command

While the Brightness/Contrast command can be used to change the brightness and contrast of an image, the Levels function is more sophisticated because you can make specific changes to the shadows, highlights, and midtones of an image.

Select [File]-[Open] from the menu bar.

The Open dialog box appears.

Open the Sample\Chapter 1\Tech03.tif file from the supplementary CD.

This image is a little dull so let's brighten it to give the objects a fresh appeal.

menu bar.

Select [Enhance]-[Adjust Lighting]-[Levels] from the Some users magnify an image to view a particularly problematic or important section when making changes to contrast. Although this is a fast way of correcting glaring weaknesses, it makes it difficult to obtain an optimal overall image setting. Therefore, it is recommended that a contrast that is appropriate for the overall image be applied before the image is magnified.

4 The right side of the histogram in the Levels dialog box is quite high, indicating that the image is quite bright. Drag the white triangular slider directly below the Input Levels histogram from the right to the left, as shown in the figure.

This brightens the already bright regions of the image and removes the light background tone.

5 Drag the black triangular slider directly below the Input Levels histogram toward the right, as shown in the figure.

This darkens the darker pixels in the image and increases the overall contrast of the picture as a result.

As you move a slider, the value in the corresponding Input Levels text field changes to reflect the new input. You can also adjust the histogram by entering the values in the text fields directly instead of moving the sliders. This is especially useful if exact values are needed.

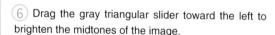

In this example, entering an intensity value of 45 in the first input Levels field (for the black slider) means that all pixels to the left of 45 will become black. A value of 195 in the third field (for the white slider) means all pixels to the right of 195 will become white. A value of 1.30 in the middle field brightens the midtone regions slightly.

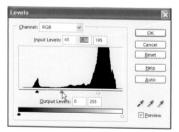

A Closer Look at the Levels Dialog Box

The Levels dialog box consists of a channel menu, a histogram, an input slider bar, and an output slider bar. The input slider bar is used to correct the brightness and contrast of images, while the output slider bar is used to set the tonal range of the image.

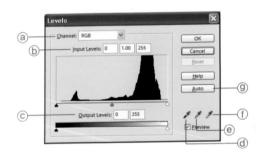

- (a) Channel: You can adjust the intensity of an image's tonal values or its red, green, or blue values by selecting the channel from the drop-down menu.
- (b) Input Levels: You can adjust the shadows, midtones, and highlights of an image by entering the values in the Input Levels text fields or by adjusting the three input sliders below the histogram.
- © **Output Levels:** You can change the overall image's tonal range by moving the two output sliders below the Output Levels text boxes. Dragging the white arrow toward the left darkens the overall image while dragging the black arrow to the right brightens the overall image.
- Set Black Point: If you click the Set Black Point eyedropper and then click on a pixel on the image, all pixels darker than the selected pixel in the image window will become black. Clicking this eyedropper on areas that are 100% black will have no effect.
- Set Gray Point: This is used to configure the midtones of the image. Clicking the Set Gray Point eyedropper on the image will apply the color contrast of the selected pixels as the midtone for the entire image.
- ① Set White Point: If you click the Set White Point eyedropper and then click on a pixel on the image, all pixels brighter than the selected pixel in the image window will become white. Clicking this eyedropper on areas that are 100% white will have no effect.
- Auto: You can automatically enhance the contrast of an image by clicking Auto. This option is the same as the [Enhance]-[Auto Levels] command in the menu bar.

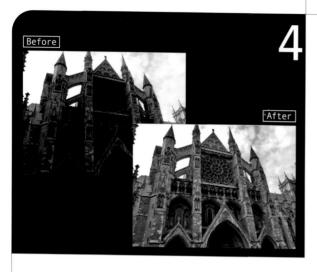

Correcting Backlighting

Backlighting often causes exposure problems in pictures. In the Before image on the left, the building is backlit by the bright, sunny sky. As you can see, the sky looks overly bright while the building and other parts of the image appear slightly dark. The Shadows/Highlights feature in Photoshop Elements will help you correct such problems.

1 Choose [File]-[Open] from the menu bar.

The Open dialog box opens.

Open the Sample\Chapter 1\Tech04.tif file from the supplementary CD.

You can see that the sky is too bright while the building is in the shadows.

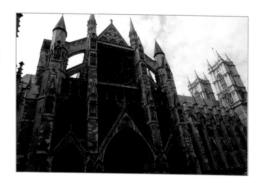

3 Select [Enhance]-[Adjust Lighting]-[Shadows/Highlights] from the menu bar.

The Shadows/Highlights dialog box appears.

4 To brighten up the building, move the Lighten Shadows slider to a value of **70%**.

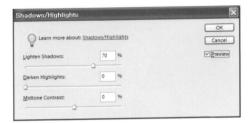

5 You will see that this only brightens up the building and that the sky's luminosity did not change.

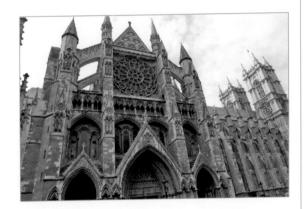

6 Now, let's darken the sky. In the Shadows/Highlights dialog box, increase the Darken Highlights value to **30%**.

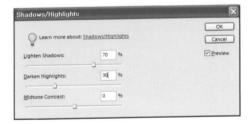

7 By darkening the sky, you can now see the clouds more clearly.

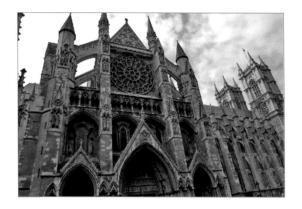

Preview

8 Because the building looks slightly washed out, let's increase the midtone contrast to bring out all the details. In the Shadows/Highlights dialog box, increase the Midtone Contrast to 20%.

ture's contrast. Combined, these functions make the Shadows/Highlights feature of Photoshop Elements per-

fect for correcting backlighting problems.

Click OK when you are done.

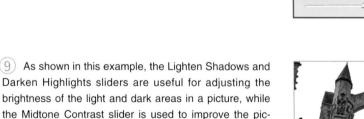

Shadows/Highlights

Lighten Shadows:

Darken Highlights:

Midtone Contrast:

Learn more about: Shadows/Highlights

+20

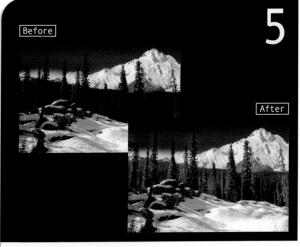

Brightening a Specific Spot

Occasionally, you may need to brighten or darken only specific areas of an image without affecting the other parts. To make such precise adjustments, you need to first select the area which you intend to work on. You also have to make sure that the corrected area blends in with the image. All this can be done easily in Photoshop Elements.

1 Select [File]-[Open] from the menu bar.

The Open dialog box appears.

Open the Sample\Chapter 1\Tech05.tif file from the supplementary CD.

This snow-covered winter picture is too dark except for the areas covered by snow.

- 4) Use the Lasso Tool to outline the dark areas.

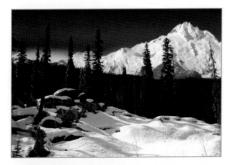

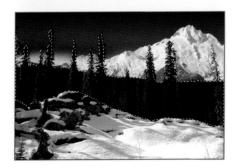

(5) Select [Select]-[Feather] from the menu bar.

The Feather Selection dialog box appears.

- 6 Set Feather Radius to 50.
- 7 Click OK.

This softens the edges of the selection and blends it in with the rest of the image.

8 Select [Enhance]-[Adjust Lighting]-[Levels] from the menu bar.

The Levels dialog box appears.

- 9 Set the Input values to 7, 2.3, and 255.
- Check the Preview option in the Levels dialog box to preview the changes made in the dialog box on the actual image.
- (10) Click OK.

The selected areas become brighter.

1) Choose [Select]-[Deselect] from the menu bar or press cm + D.

This deselects the selection.

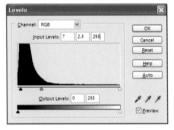

40 Digital Photo Retouching Techniques

Manipulating Colors

You can tweak colors in Photoshop Elements as easily as a chameleon changes the color of its skin. In this chapter, you will learn a combination of techniques that will let you correct an image's color or create some interesting visual effects. For instance, you will learn to turn a color picture (or just portions of one) black-and-white, create a sepia-toned image, and turn a photo of summer into fall. The best part is that by the end of this chapter, you will be able to create a multitude of new images from just one picture.

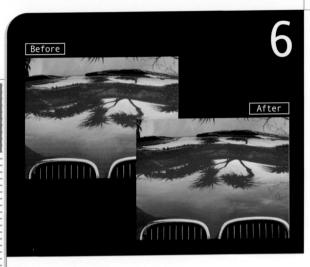

Changing a Color

You can easily change the hue, saturation, and brightness of an image in Photoshop Elements with the Hue/Saturation command. This feature for improving overall colors is also useful when you only want to change a specific color. You can, for instance, make all the blues in the image appear darker without affecting the rest of the image. The command also lets you create monotone or duotone images from black-and-white or color images.

1) Select [File]-[Open] from the menu bar.

The Open dialog box appears.

Open the Sample\Chapter 2\Tech06.tif file from the supplementary CD.

In the following steps, you will learn to change the color of the car from red to blue.

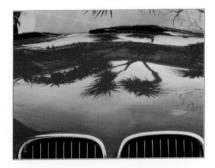

3 Select [Enhance]-[Adjust Color]-[Adjust Hue/Saturation] from the menu bar.

The Hue/Saturation dialog box appears.

A) Select **Reds** from the Edit menu.

Now you can only edit the red areas in the image.

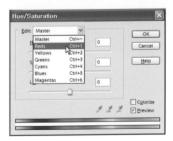

5 Move the Hue slider to a value of -110.

This changes the color of the car from red to a purplish blue.

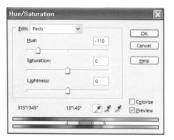

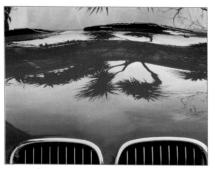

6 Select Magenta from the Edit menu.

This limits you to editing the purplish areas in the image.

If you select Master from the Edit menu, your changes will affect the entire image. You can still change the color of the car in Master mode; but to do this, you will need to use the Lasso or Magic Wand Tools to select the car before changing the color values in the Hue/Saturation dialog box.

Move the Hue slider to a value of -100.

This removes the purplish tones.

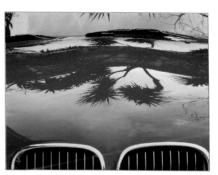

- (8) Move the Saturation slider to +60.
- Olick OK.

The car is now a brighter blue.

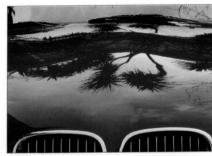

A Closer Look at the Hue/Saturation Dialog Box

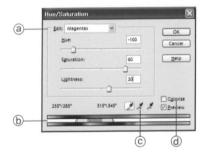

- (a) **Edit:** You can choose to edit only one color in the image by selecting it from this menu. To edit all the colors in the image, choose Master.
- (b) Color bars: The top color bar shows the color distribution of the original image. The bottom color bar shows the color distribution after making the Hue adjustments.
- © **Eyedropper:** The eyedropper is only available if you selected the Master option from the Edit menu. The eyedropper is useful for making adjustments to different colors in the image using the same values.
- @ Colorize: You can turn an image into a monotone (black-and-white) or duotone (black, white, and one color) by selecting this option.

Replacing a Color

In this tutorial, we will use the Replace Color command to turn the purplish hue in the sky to light blue. Unlike the Hue/Saturation command, the Replace Color command lets you select the specific color and area for modification

1 Select [File]-[Open] from the menu bar.

The Open dialog box appears.

Open the Sample\Chapter 2\Tech07.tif file from the supplementary CD.

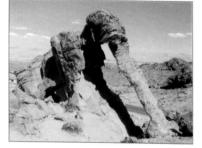

Select [Enhance]-[Adjust Color]-[Replace Color] from the menu bar.

The Replace Color dialog box appears.

- Select the Eyedropper Tool (

 ▼).
- 5) Click on the purplish tones in the sky to select these areas.

The color selected using the Eyedropper Tool appears in the Sample window of the Replace Color dialog box.

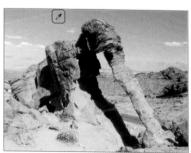

6 Move the Fuzziness slider to a value of 130.

This selects the majority of the purplish areas in the sky so you can correct all the other purplish areas in addition to what you have already selected.

(7) Move the Hue slider under Transform to a value of -20.

The selected color turns bluish.

In the Replace Color dialog box, check the Selection option in order to view the extent of your selection in the preview box. The white areas represent the areas selected for modification, while the black areas will not be affected by any color corrections.

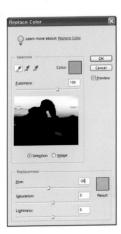

8 Click OK.

The image now has the original bluish tone, instead of a reddish one.

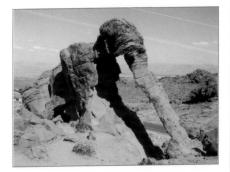

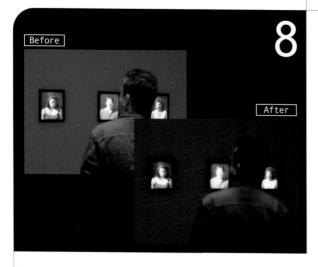

Desaturating Part of An Image

When you turn a color image black-and-white using the Remove Color command in Photoshop Elements, the process is known as desaturation. In this chapter, you will learn to desaturate only part of a color image, as the juxtaposition of color and black-and-white areas creates an interesting visual effect. This is a technique that is often used in creating print, video, and digital works.

1) Select [File]-[Open] from the menu bar.

The Open dialog box appears.

Open the Sample\Chapter 2\Tech08.tif file from the supplementary CD.

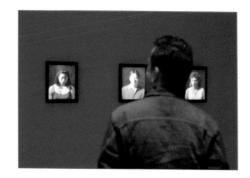

- Pick the Selection Brush Tool () from the toolbox.
- 4 In the options bar, select a **Soft Round 65 pixels** brush from the brush presets pop-up palette and set Mode to **Mask**.

The Lasso Tool and the Magic Wand Tool are normally used to make detailed and exact selections. But in this example, a clear-cut border between the color and black-and-white areas will make the image look unnatural. So the Selection Brush Tool is used instead to create a less obtrusive-looking border between the areas.

5 Click and drag the Selection Brush Tool over the picture frames in the image.

The picture frames are painted over in red, indicating that a mask has been applied.

To subtract from the selection, press the Att key as you use the Selection Brush Tool.

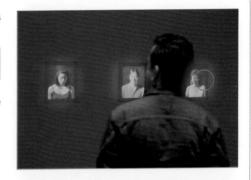

6 Change the Mode in the options bar to Selection.

The red mask color disappears and a selection border appears around the unmasked areas.

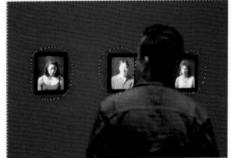

Change the size of the brush to **27 pixels** in the options bar.

A smaller brush size lets you define a more precise selection border.

8 Click and drag the Selection Brush Tool around the edges of the photos to add to the selection.

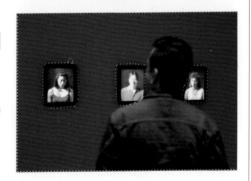

 Select [Enhance]-[Adjust Color]-[Remove Color] from the menu bar.

This turns the selection into shades of gray.

One [Select]-[Deselect] from the menu bar or press $\mathbb{C}_{m} + \mathbb{D}$.

This deselects the selection.

(1) Click and drag the Background layer in the Layers palette onto the Create a New Layer icon ((a)) to make a copy of that layer.

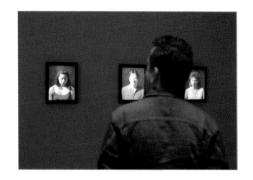

(2) Press Shift + Ctrl + U to turn the copy black-and-white.

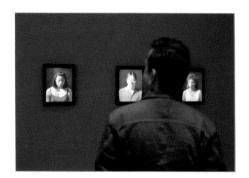

3 Select [Filter]-[Blur]-[Gaussian Blur] from the menu bar.

The Gaussian Blur dialog box appears.

(14) Enter a Radius of 7 pixels. Click OK.

This applies a blur to the copied black-and-white background laver.

(5) Change the blending mode in the Layers palette from Normal to **Overlay**. By setting the blending mode to Overlay, the blurred Background copy acts as a screen through which the background shows. This has the effect of softening and blurring the entire image and keeping our interest on the colored areas.

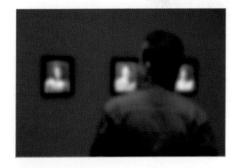

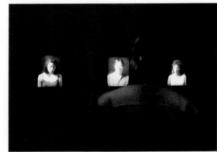

(V) The Difference Between Grayscale Mode and Desaturation

At first glance, it may seem that there is no difference between turning images black-and-white using the [Image]-[Mode]-[Grayscale] or the [Enhance]-[Adjust Color]-[Remove Color] commands. As you get more familiar with the program, however, you may soon realize that images turned into the Grayscale Mode cannot have their colors restored, but those desaturated using [Enhance]-[Adjust Color]-[Remove Color] can be made as good as new. This is because desaturated images still have their color information intact.

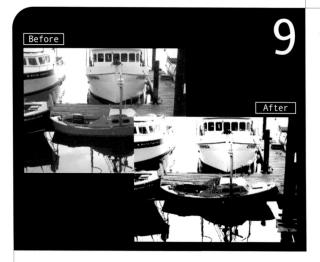

Turning Color Photos into Black-and-White Images

Sometimes, it is only after a shoot that I discover a shot would have looked better in black-and-white. On other occasions, I turn my color photos into black-and-white images at the model's request or because I need the pictures to create some special moods. Black-and-white images are particularly suitable for journalistic style photography or for evoking a sense of nostalgia. In this section, you will learn to turn a color image into a high-contrast black-and-white image in order to emphasize the lines and shapes in the image.

1) Select [File]-[Open] from the menu bar.

The Open dialog box appears.

- (2) Open the Sample\Chapter 2\Tech09.tif file from the supplementary CD.
- 3 Select [Enhance]-[Adjust Color]-[Remove Color] from the menu bar.

This removes all the color information so the color image is rendered in shades of gray.

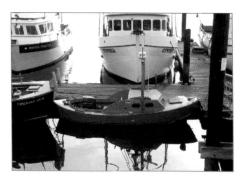

4 Select [Enhance]-[Adjust Lighting]-[Levels] from the menu bar.

The Levels dialog box appears.

5 In the Input Levels text boxes, enter **50**, **0.85**, and **200**, respectively.

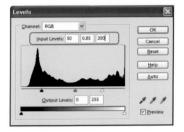

6 Click OK.

This will increase the highlights and midtones in the image.

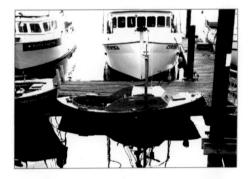

Click and drag the Background layer in the Layers palette onto the Create a New Layer icon () to make a copy of the layer.

8 Select [Filter]-[Adjustments]-[Threshold] from the menu bar.

The Threshold dialog box appears.

Move the Threshold Level slider to a value of 60.

(10) Click OK.

The image changes from shades of gray to pure black-and-white.

The Threshold command transforms color and grayscale images into high-contrast black-and-white images. Pixels lighter than the stated threshold value will be converted to white, while pixels darker than the threshold value will be turned into black. In general, the higher the threshold value, the more black the image will contain.

In the Layers palette, change the blending mode to **Overlay** for any layers with altered threshold values.

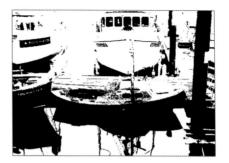

(2) In the same palette, change the layer's Opacity to 60%.

The result is a high-contrast black-and-white image.

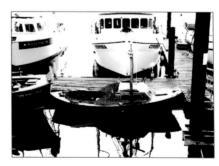

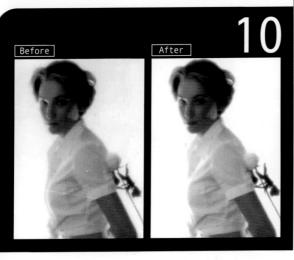

Coloring Black-and-White Photographs

If you have some old, black-and-white family photos, try turning them into color images in Photoshop Elements. The colors will inject vibrancy into the images and give them a different kind of look. But no matter how the images turn out, one thing is for sure—your pet project will get everyone in the family talking.

- 1 Scan a black-and-white portrait shot (e.g., a black-and-white passport photo) and save it on your computer.
- Select [File]-[Open] from the menu bar. When the Open dialog box appears, look for the drive where you saved the scanned image and open it.

Select [Image]-[Mode]-[RGB Color] from the menu bar.

The RGB color mode is indicated on the title bar.

- 4 Select the Selection Brush Tool () from the tool-box.
- 5 In the options bar, set the brush size to **27 pixels**, the mode to **Selection**, and the hardness to **0%**.

6 Click and drag the tool over the model's skin to select it.

To make precise selections, you may need to change the brush size as you work. When selecting a small area, for instance, use a smaller brush size.

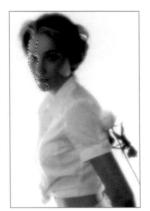

7 Select [Select]-[Save Selection] from the menu bar.

The Save Selection dialog box appears.

8 Enter the name **Skin** for the selection. Click OK.

Use [Select]-[Save Selection] from the menu bar to save selections, and use [Select]-[Load Selection] to load selections.

9 Press cm+v or select [Enhance]-[Adjust Color]-[Adjust Hue/Saturation] from the menu bar.

The Hue/Saturation dialog box appears.

Oheck the **Colorize** option. Set Hue to **10**, Saturation to **21**, and Lightness to **4**.

(11) Click OK. Press cm+D to deselect.

This applies a flesh-tone to the woman's skin.

(2) Select the Selection Brush Tool (2) from the toolbox. Click and drag over the woman's hair to select it.

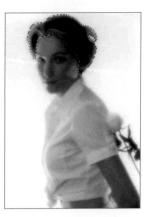

3 Select [Select]-[Save Selection] from the menu bar. Name the selection as **Hair** in the Save Selection dialog box. Click OK.

Press cm+v or select [Enhance]-[Adjust Color]-[Adjust Hue/Saturation] from the menu bar. Check the **Colorize** option, and set Hue to **23** and Saturation to **30** in the Hue/Saturation dialog box. Click OK.

This changes the color of the woman's hair as shown.

Press Ctrl + D to deselect.

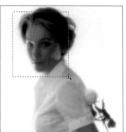

(6) Select the Selection Brush Tool (2) from the toolbox. In the options bar, set the brush size to **9 pixels**. Click and drag the tool over the right pupil to select it.

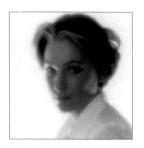

Press ctd+U or select [Enhance]-[Adjust Color]-[Adjust Hue/Saturation] from the menu bar. In the Hue/Saturation dialog box, check the **Colorize** option and set Hue to **260**, Saturation to **25**, and Lightness to **-15**. Click OK. Press ctd+D to deselect.

This changes the color of the woman's eyes as shown.

- (8) Select the Selection Brush Tool (7) and set the brush size to **27 pixels** in the options bar.
- 19 Select the woman's cheeks.

Open the Hue/Saturation dialog box. Check the Colorize option and set Hue to 0, Saturation to 25, and Lightness to 0. Click OK and deselect the cheeks. This adds color to the woman's cheeks.

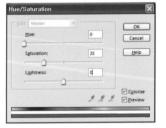

As in the preceding steps, use a selection brush of **9 pixels** in size to select the woman's lips.

Open the Hue/Saturation dialog box. Check the Colorize option and set Hue to 0, Saturation to 25, and Lightness to 0. Click OK and deselect the lips. This changes the color of the woman's lips.

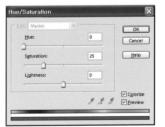

23 Select the Burn Tool (a) from the toolbox. In the options bar, set Size to **2 pixels**, Range to **Midtones**, and Exposure to **30%**.

24 Click and drag the tool over the woman's eyebrows and eyelids to sharpen the features.

Although you can correct the image with the Exposure set to 100%, this can over-enhance the effect you want to create. It is more effective to use a lower Exposure of 20% to 30% and then apply it several times to achieve the effect.

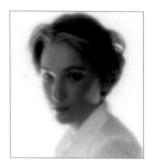

25 Select [View]-[Actual Pixels] from the menu bar.

This displays the colored image in its actual size.

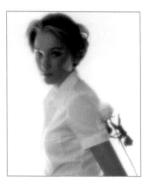

26 Select the Selection Brush Tool () and set the brush size to **9 pixels** in the options bar. Select the rose petals and open the Hue/Saturation dialog box. Check the **Colorize** option, and set Hue to **35**, Saturation to **18**, and Lightness to **7** to change the color. Click OK. Press cm + D to deselect.

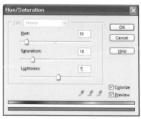

▲ Changing the color of the rose petals

Next, select the leaves and open the Hue/Saturation dialog box. Check the **Colorize** option and set the Hue to **150**, Saturation to **15**, and Lightness to **-15** to change the color of the leaves.

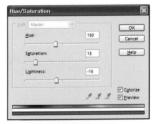

▲ Changing the color of the leaves

Select [Enhance]-[Adjust Lighting]-[Brightness/Contrast] from the menu bar. In the Brightness/Contrast dialog box, set the Brightness to 15 and Contrast to 10. Click OK. This changes the contrast of the image, as shown.

To preserve the selection borders you have made, you should save images in Photoshop's PSD file format. If an image is saved in another format, you could lose the selection borders.

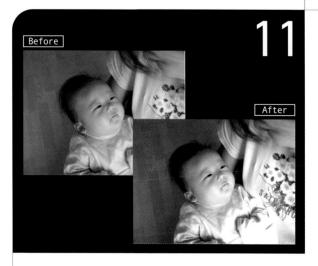

Creating a Sepia-Toned Picture

Vintage photographs often come in a single color tone. A common example is the sepia-tone picture, which consists of predominantly brown tones. Sepia-toned images these days usually feature people, although this really depends on the photographer's preference. This section describes the steps needed to change colorful photographs into sepia-toned ones.

1) Select [File]-[Open] from the menu bar.

The Open dialog box appears.

- Open the Sample\Chapter 2\Tech11.tif file from the supplementary CD.
- 3 Select [Enhance]-[Adjust Color]-[Remove Color] from the menu bar to turn the image into a black-and-white one.

4 Select [Enhance]-[Adjust Lighting]-[Levels] from the menu bar.

The Levels dialog box appears.

5 In the Input Levels text boxes, enter the values **10**, **0.95**, and **220** to increase the black-and-white contrast of the image.

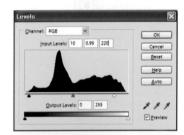

6 Click OK.

The resulting image has a higher contrast level than the original one.

Choose [Layer]-[New Adjustment Layer]-[Photo Filter] from the menu bar. When the New Layer dialog box appears, click OK.

You will see the adjustment layer, Photo Filter 1, added to the Layers palette. The Photo Filter dialog box will also appear.

8 In the Photo Filter dialog box, check that the Filter option is selected and then select Sepia from the Filter drop-down menu. Set the Density to 100% and click OK.

The Filter drop-down menu contains a list of commonly used photo filters. Alternatively, you can also set the color of the filter by clicking on the color swatch next to the Color option.

9 The result is a sepia-toned image.

To undo the changes and restore the original picture, select the adjustment layer and click on the Delete Layer icon () in the Layers palette. You will be asked if you want to delete the layer mask. Click Yes. Click on the Delete Layer icon () again. You will be asked if you want to delete the layer. Click Yes.

Blending Colors

Like the Photo Filter, the Color Variations command, which is accessed by selecting [Enhance]-[Adjust Color]-[Color Variations] from the menu bar, can be used to alter the tone of an image. The key difference between the Photo Filter and the Color Variations command is that the latter lets you selectively tailor your tonal changes. With the Color Variations command, you can choose to selectively alter the highlights, midtones, or shadows. The Photo Filter, on the other hand, will apply the selected tone to the entire image.

The Color Variations dialog box is very userfriendly. Simply follow steps 1 through 3 in the dialog box to alter the tone of an image.

In school, all of us learned the artist's color wheel, which shows us how color inks combine to form new colors. The primary colors in an artist's color wheel are cyan, magenta, and yellow. Theoretically, these three colors should combine to form black, but the impurities in the inks produce a deep gray instead. In order to achieve pure black, color printers come with not only cyan (C), magenta (M), and yellow (Y) inks, but also a black (K) ink. So for printing, we use the CMYK color model.

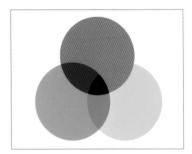

▲ The artist's color wheel

The colors on a computer screen, however, are actually light rays, so they do not have the same properties as color inks. The three primary colors of light are red (R), green (G), and blue (B). When these three colors are combined, we get white instead of black. Take some time to study the RGB color wheel, as shown here, so that you will find it easier to change colors on a computer next time.

▲ The RGB color wheel

Turning Summer into Fall

Every season has its representative colors—but to me, fall is the most colorful and most beautiful season. In this section, you will learn how to turn green summer leaves into reddish or yellowish autumn colors.

1 Select [File]-[Open] from the menu bar.

The Open dialog box appears.

Open the Sample\Chapter 2\Tech12.tif file from the supplementary CD.

3 Select [Enhance]-[Adjust Color]-[Adjust Hue/Saturation] from the menu bar.

The Hue/Saturation dialog box appears.

(4) Change the Hue setting to -30.

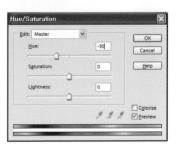

(5) Click OK.

The overall image now has a brownish tone.

- 6 Select the Lasso Tool () from the toolbox.
- In the options bar, set Feather to 20 pixels.

- 8 Click and drag over a bunch of leaves on the left side of the image to select them.
- To soften the edges of the selection border, always set a Feather value greater than 0 before changing the color. The greater the Feather value, the fuzzier the edges. A Feather value of 0 will give the selection border an abrupt edge.
- Olick the Add to Selection icon () in the options bar.

Olick and drag the tool over the leaves on the right side of the image to add them to the selection.

11) Press Ctrl + U or select [Enhance]-[Adjust Color]-[Adjust Hue/Satu ration] from the menu bar.

The Hue/Saturation dialog box appears.

- Set Hue to -55 and Saturation to +25.
- (13) Click OK.

This changes the colors of the leaves to a warm autumn red.

14 In the options bar of the Lasso Tool (2), click on the New Selection icon ().

Select the leaves on the left side of the image, as shown.

(6) Click on the Add to Selection icon () in the options bar.

Click and drag the tool over the other two areas, as shown.

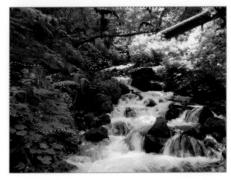

Press cm+u or select [Enhance]-[Adjust Color]-[Adjust Hue/Saturation] from the menu bar.

The Hue/Saturation dialog box appears.

- 19 Set Saturation to +65.
- 20 Click OK.

This turns the selected areas yellow.

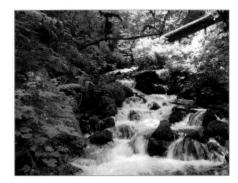

21 In the options bar of the Lasso Tool (2), select New Selection (2).

22 Select the leaves in the lower-left corner.

- 23 Open the Hue/Saturation dialog box. Set Hue to -70.
- 24 Click OK. Press Ctrl + D to deselect.

This turns the selected leaves slightly purplish.

Making Detailed Color Changes

There are many ways to change the color in a specific area of an image, but most of these methods require that you select the area that you wish to change. The problem with making a selection first is that you could end up with a distinct and unnatural looking border around the altered area. In this chapter, you will learn to use the Color Replacement Tool to change specific colors without making a selection.

1 Choose [File]-[Open] from the menu bar.

The Open dialog box opens.

Open the Sample\Chapter 2\Tech13.tif file from the supplementary CD.

3 Select the Color Replacement Tool (27) from the toolbox. In the options bar, set the Brush Diameter to **60 pixels**, Sampling to **Once**, and Limits to **Discontiguous**.

4 Click on the Set Foreground Color icon (♠*) in the toolbox and set the RGB values to 245, 125, and 5, respectively. Click OK.

(5) Click on the center part of the butterfly, as shown here.

You can see that the brownish tint has been replaced by the orange hue that you selected in the previous step.

The crosshair in the center of your pointer determines the color that will be replaced. For example, if you click with the crosshair on a black area and then start dragging, only the black areas will be replaced—even if you drag over other colors.

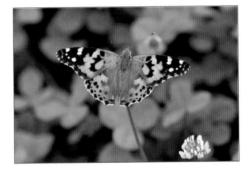

(6) Click and drag over the center part of the butterfly, as shown.

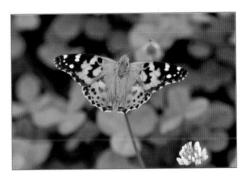

Select the Eyedropper Tool () from the toolbox. Hold down the Alt key and click on a black part of the butterfly.

In the toolbox, you can see that the background color has been set to black.

8 Select the Color Replacement Tool () from the toolbox and choose **Background Swatch** from the Sampling drop-down menu in the options bar.

Olick on the Set Foreground Color icon (ℙ) in the toolbox and change the RGB values to 245, 5, and 5. Click OK.

- Olick and drag over the black areas of the butterfly.
- 11) Because Sampling was set to Background Swatch in step 8, you can see that only areas in the background color (black) are replaced with red.

A Closer Look at the Color Replacement Tool Options Bar

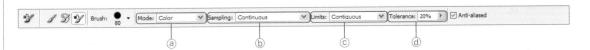

- (a) Mode: Determines the blending mode used. You can choose to replace the Color, Hue, Saturation, or Luminosity in the image.
- **Sampling**: Choose from three sampling options. The Continuous option samples the color to be changed continuously, which means the tool will sample as you drag. The Once option samples the color from the first click of your drag. This option is useful when you want to replace a specific color. The Background Swatch option samples with the selected background color. This means that the tool will only replace a color in the image if it matches the background color.
- © Limits: The Limits option allows you to decide if the color will be replaced in a contiguous or discontiguous manner. The Contiguous option only replaces the specific "patch" of color (or colors) that you click with the mouse pointer. The Discontiguous option replaces all instances of the selected color in the image, whether they are connected to the location you click or not.
- Tolerance: The Tolerance value in the options bar determines the range of colors that will be replaced by the Color Replacement Tool. A low tolerance value only replaces colors that are very similar to the selected color, while a high tolerance value replaces a wider range of colors.

The difference between the Contiguous option (left) and Discontiguous option (right).

3...

40 Digital Photo Retouching Techniques

Enhancing Portraits

While you can reshoot a landscape if you really want to, retaking a bad portrait shot is more difficult. You need to find another date and location that will fit into your model's schedule. In the worst-case scenario, you may never get the chance again. So instead of a reshoot, try correcting the offending portrait in Photoshop Elements. It will save you time, and you can even make your model better-looking than he or she really is.

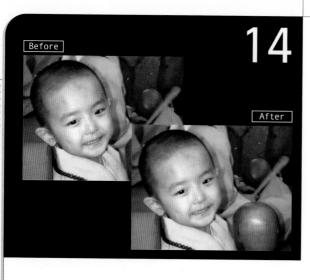

Removing Red Eyes

When you use a flash to take a picture of people or animals in a dark environment, your subjects can end up with red eyes. This effect is quite common, and you have probably seen such images before. In this section, you will learn to use Photoshop Elements 3.0's Red Eye Removal Tool to remove red eyes. The Red Eye Removal Tool, which replaces the Red Eye Brush Tool found in older versions of Photoshop Elements, makes it easier than ever to correct problems with red-eye.

1 Select [File]-[Open] from the menu bar.

The Open dialog box appears.

Open the Sample\Chapter 3\Tech14.jpg file from the supplementary CD.

Note that the subject has red eyes.

This step is optional but highly recommended, as you will need a magnified view to work on an area as small as the pupil of the eye.

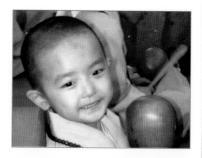

4 From the toolbox, select the Red Eye Removal Tool (). In the options bar, check that the Pupil Size is set to 50% and the Darken Amount to 30%.

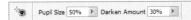

5 Click and drag over an eye to remove the red glow.

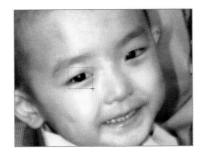

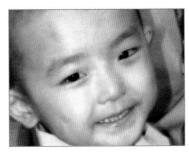

6 Repeat the step on the other eye.

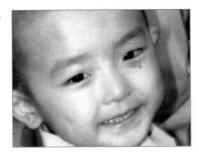

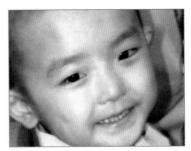

Ned Eye Removal Tool Options

Pupil Size: A small pupil size will create a wider tonal range in the pupil. You will see the highlight created by the flash turning into shades of darker gray before turning completely black. A large pupil size, on the other hand, will create a smaller tonal range with fewer shades of gray so the pupil will appear to be darker. The effect of the Pupil Size setting is very subtle and you may not even notice it.

Darken Amount: Determines how dark the pupil will turn out.

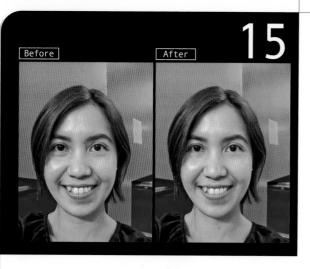

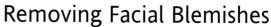

The Spot Healing Brush and Healing Brush tools are essential for removing facial blemishes such as freckles and wrinkles. The Spot Healing Brush Tool, which is new to Photoshop Elements 3.0, is particularly effective, as it requires only one step to remove all sorts of unwanted artifacts, such as dust and scratches. In this exercise, you will learn to use these two brushes as well as the Remove Color Cast command. We'll also cover the new Cookie Cutter Tool and Photo Compare command.

1 Select [File]-[Open] from the menu bar.

The Open dialog box appears.

Open the Sample\Chapter 3\Tech15.tif file from the supplementary CD.

You can see that the image has an orange color cast.

3 Select [Enhance]-[Adjust Color]-[Remove Color Cast] from the menu bar. When the Remove Color Cast dialog box appears, position your pointer (which has turned into an eyedropper) over the white part of the model's eyes. Click once to set this as the white point for the program to reference.

- 4 The image now looks less orange.
- Next, we'll take care of the model's skin blemishes. Zoom in on the model's face. Select the Spot Healing Brush Tool () from the toolbox. Set the brush size to **16 pixels** in the options bar.

6 Position your pointer over the spot as shown and click once.

Repeat step 6 on a few isolated spots.

8 To remove the group of freckles on the model's cheek, select the Healing Brush Tool () from the toolbox. Hold down the Att key and click on the position as shown to set a reference point for the tool.

The Healing Brush Tool works by copying and blending the area from the reference point to the area that is brushed over.

Oheck that the brush size is set to 30 pixels and the Mode is set to Darken in the options bar. Brush over the group of freckles, as shown.

If you did not remove the freckles successfully, go back a few steps in the Undo History palette and try again until all the freckles are removed.

11) Select the Spot Healing Brush Tool (22) and drag over the lines under the right eye as shown.

(12) Repeat the step on the other eye.

Do not remove all of the under-eye-lines, as the face will look very plastic if there are no lines at all.

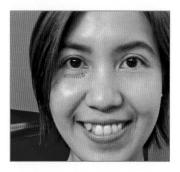

Address Processing Elements 2.8 (Editor)-incompage year, Processing
Too Sets States Committee State States Stat

(3) In the same way, remove the lines from the neck. When you are done, save the image.

After you have touched up the image, you can use the Cookie Cutter Tool () to cut the image into a fun shape. With the Cookie Cutter Tool selected, choose the Talk 1 shape from the options bar.

The Cookie Cutter Tool is new to Photoshop Elements 3.0 and lets you choose from a set of shapes with which to cut your image.

(5) Click and drag over the image. The **Talk 1** bounding box will appear. To adjust the shape of **Talk 1**, click and drag on the handles of the bounding box. To reposition **Talk 1**, simply click within the bounding box and drag.

16 Position **Talk 1** as shown. When you are done, double-click within the bounding box to cut the image according to the shape.

17 Save the file. Close all the files and click on the Photo Browser button in the shortcuts bar.

The files have to be closed in the Standard Edit window so that they can be accessed in the Photo Browser.

(18) In the Photo Browser window, select the tech15.tif thumbnail and select [View]-[Photo Compare] from the menu bar.

If you can't find the tech15.tif thumbnail, select [File]-[Get Photos] from the menu bar and select the location of the file.

(19) In the Photo Compare screen, you can place two images side by side for comparison. To change the image to be compared, click on the image and click on a thumbnail on the right side of the screen.

The Photo Compare command is new to Photoshop Elements 3.0. The command is great for those moments when you have a hard time deciding between similar photographs or images.

(20) When you are done comparing the images, hit the Esc key to revert to the Photo Browser. The image that was selected as the 1st image in the Photo Compare screen will be selected in the Photo Browser.

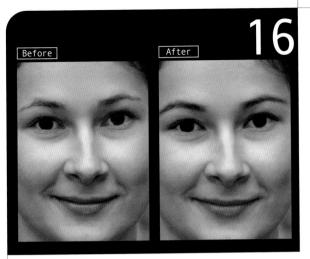

16 Applying Makeup

Some cosmetic counters or make-over studios are equipped with a computer system that captures a person's face and shows on screen the effect that their products will have on the face. It goes to show how easy it is now to change how a person looks using a computer. The most important thing you need to remember in this section is to keep the makeup natural.

1 Select [File]-[Open] from the menu bar.

The Open dialog box appears.

- Open the Sample\Chapter 3\Tech16.tif file from the supplementary CD.
- 3 Press ctrl + + to zoom in on the face.

A Select the Selection Brush Tool () from the toolbox. Set Size to 5 pixels, Mode to Mask, and Hardness to 100%.

A masked area is protected from the changes made to the rest of the image. You can invert a masked area by clicking [Select]-[Inverse]. The previously unmasked areas will become masked instead.

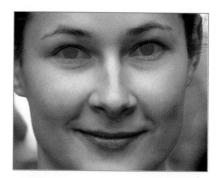

6 Click the Set Foreground Color icon in the toolbox.

The Color Picker dialog box appears.

- Set the RGB values to 0, 246, and 255, respectively.
- (8) Click OK.

The foreground color changes, as shown.

Select the Brush Tool () from the toolbox. In the Brush Tool options bar, set Size to 20 pixels and Opacity to 15%.

Reducing the opacity makes the color more transparent.

Olick and drag the Brush Tool () over the upper eyelids as if applying eye shadow.

Click the Set Foreground Color icon in the toolbox to change to another eye shadow color. In the Color Picker dialog box, set the RGB values to **0**, **12**, and **255**, respectively. Click OK.

This darker blue will be used for the inner edges of the upper eyelids.

12 In the Brush Tool options bar, set Size to 12 pixels and Opacity to 22%.

The smaller brush size enables you to line the inner edges of the eyelids more accurately.

(3) Click and drag along the inner edges of the upper eyelids, as shown.

This completes the make-up on the upper eyelid.

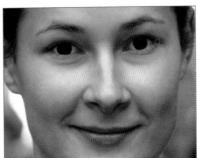

Click on the Set Foreground Color icon in the toolbox. In the Color Picker dialog box, set the RGB values to 255, 150, and 0, respectively. Click OK.

(5) In the Brush Tool options bar, set Size to **20 pixels** and Opacity to **10%**.

16 Draw along the edges below the eyes.

Select the Burn Tool (<a>) from the toolbox. In the options bar, set Size to **5 pixels** and Exposure to **50%**.

(8) Click and drag over the edge of the eyelids as if applying eyeliner.

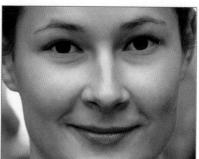

20 Click and drag over the eyebrows to make them look more even.

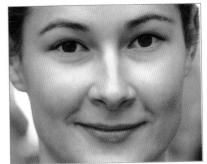

Note that the eye makeup has covered the eyelid lines. In the options bar, set Size to **5 pixels**. Click and drag the Burn Tool to draw the eyelid lines back in.

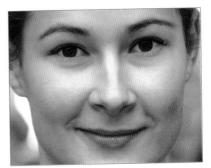

22 In the options bar, set Size to **3 pixels**. Click and drag the Burn Tool outwards from the eyes as if applying mascara.

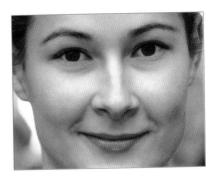

23 Click the Set Foreground Color icon in the toolbox to change to a lipstick color. In the Color Picker dialog box, set the RGB values to 251, 6, and 6, respectively. Click OK.

Select the Brush Tool () from the toolbox. In the Brush Tool options bar, set Size to **15 pixels** and Opacity to **10%**.

25 Draw over the lips.

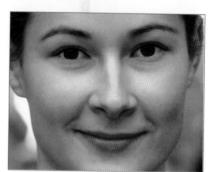

Select the Burn Tool () from the toolbox. In the options bar, set Size to 10 pixels.

Press ctrl+0 to view the entire image.

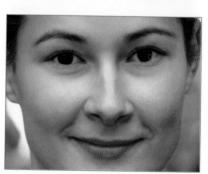

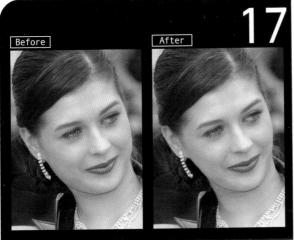

Sharper Chin

A major factor in beauty is to have a face with nearperfect symmetry. You may not realize it, but many of us have fairly asymmetrical faces. In this section, you will create a more symmetrical face by enlarging the left eye of the model. (The model's left eye is slightly smaller than her right.) You will also learn to use the Liquify command to make the left side of her face slimmer, with a sharper chin.

Select [File]-[Open] from the menu bar.

The Open dialog box appears.

Open the Sample\Chapter 3\Tech17.tif file provided on the supplementary CD.

Select [Filter]-[Distort]-[Liquify] from the menu bar. The Liquify dialog box appears.

Select the Zoom Tool () in the Liquify dialog box. Click and drag over the right jaw line for a magnified view.

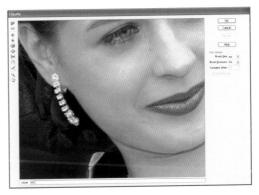

- Select the Warp Tool (₩) in the Liquify dialog box. Under Tool Options, set Brush Size and Brush Pressure to 50.
- 6 Click and drag the jaw line inward for a sharper chin.

A Brush Pressure of 50%, compared to, say 100%, will move the jaw line more gradually.

Click and drag the tool over the jaw line again to smooth out any rough edges.

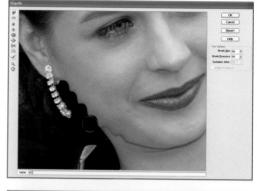

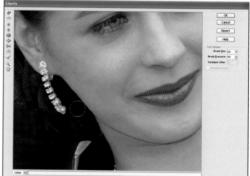

8 Select the Hand Tool (). Click and drag the image to move the view to the other jaw. Select the Warp Tool () and repeat steps 7 and 8 on the right jaw line. Click OK.

■ A slimmer-looking face

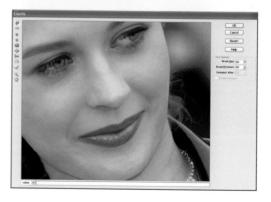

 $\begin{tabular}{ll} \end{tabular}$ Select the Zoom Tool ($\end{tabular}$) from the toolbox. Click and drag over the eyes to zoom in on them.

O Select the Lasso Tool () from the toolbox. In the options bar, set Feather to 12 pixels.

Click and drag over the left eye to select it. Press Ctrl + C to copy the selection.

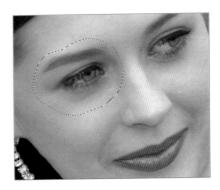

12) Press Ctrl + V to paste the copy onto the image.

■ Note that the copy is pasted on a new layer. 3 Select [Image]-[Transform]-[Free Transform]. A bounding box with adjustment handles will appear over the selection.

Hold down the Shift + Alt keys, and drag the adjustment handle on the lower-right corner slightly outward. Hit Enter.

The Shift key ensures that the image is resized proportionally, while the Alt key ensures that the image's center point remains unchanged. Always press the Shift key before the Alt key. Pressing the Alt key and then the Shift key will cause image distortion.

 $\fill \fill \fil$

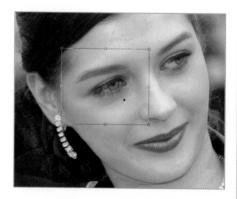

16 Press Ctrl + 0 to view the entire image.

When modifying a face, always make sure that the results look natural. Don't go overboard or you may end up with awkward and unnatural features.

Select [Layer]-[Flatten Image] from the menu bar.

This combines all the layers created when you copied and pasted selections, and merges them with the Background layer.

18 Select [File]-[Save As] and save the completed image in a folder.

▲ Flattening the layers

The point of flattening layers is to reduce the file size fout before you do so, it is advisable to first save the image as a .PSD file, which retains layer information. If you flatten the layers without saving as a PSD file, you will not be able to access the layers again.

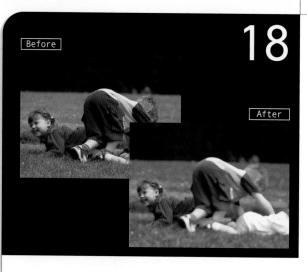

Emphasizing a Subject

A good way to make a subject stand out in a picture is to turn the background black-and-white while leaving the subject in color. Another way is to blur the background while keeping the subject in focus. In this section, you will learn to use both methods to highlight a subject.

1 Select [File]-[Open] from the menu bar.

The Open dialog box appears.

Open the Sample\Chapter 3\Tech18.jpg file from the supplementary CD.

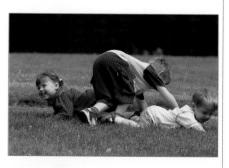

③ From the toolbox, select the Selection Brush Tool (☑). Next, change the brush size to **35 pixels** and set the Hardness to **0%** in the options bar.

4 Drag along the girl's outline in the picture.

You may find it necessary to zoom in on the girl as you work.

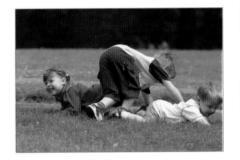

5 After making a selection around the shape of the girl, make sure you brush over the area inside to select the entire girl.

The Selection Brush Tool is used to select the girl because this will create a selection with a smooth border. It would have been more difficult to make a smooth selection with the other selection tools.

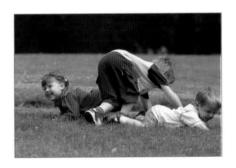

6 To make the selection border even smoother, click [Select]-[Feather] from the menu bar and set the Feather Radius to **10 pixels** in the Feather Selection dialog box.

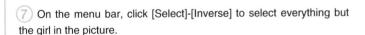

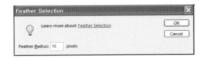

8 On the menu bar, click [Enhance]-[Adjust Color]-[Remove Color] to turn everything but the girl black-andwhite.

Select [Filter]-[Artistic]-[Paint Daubs] from the menu bar. When the Paint Daubs dialog box appears, click on the 100% icon on the lower-left corner and select [Fit in View].

10 In the Paint Daubs dialog box, set the Brush Size to 20 and Sharpness to 10. Click OK.

Press cm + H to hide the selection border. This will let you have a good look at the image without the distracting selection border. Pressing cm + H again will show the selection border.

You can see that the black-and-white area has been simplified.

This has the effect of focusing the viewer's attention on the girl.

To blur the black-and-white area further, click [Filter]-[Blur]-[Gaussian Blur] and set the Radius value to **2 pixels**. Click OK.

13) Press Ctrl + D to deselect the black-and-white area.

Opening Closed Eyes

When taking group shots, the photographer cannot give everyone at the shoot his undivided attention, and so it is common to find one or two persons with their eyes closed in group photos. To make matters worse, group photos are usually taken to remember a special time or event. So if you find your subject's eyes closed in a special or important photograph, try this technique for opening closed eyes.

1) Select [File]-[Open] from the menu bar.

The Open dialog box appears.

Open the files Sample\Chapter 3\Tech19.tif and Sample\Chapter 3\Tech19-1.tif from the supplementary CD.

The subject's eyes are closed in the first file and opened in the second. We will use the opened eyes from the second picture to rectify the problem in the first picture.

Select the Lasso Tool () from the toolbox. Set Feather to 7 pixels.

A Select the eyes in the Tech19-1.tif image.

Select the Move Tool () from the toolbox. Click and drag the eyes from the **Tech19-1.tif** image to the **Tech19.tif** image.

| Layer 1 | More 1) | Layer 1 | Layer 1 | More 2) | Background | Garage 2 | Garage 3 | G

▲ The eye selection is added as a new layer.

▲ Dragging the selection from one file to another

6 Select [Image]-[Rotate]-[Flip Layer Horizontal] from the menu bar.

This flips the newly added eyes horizontally so that they are oriented the same way as the face.

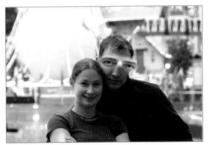

▲ Fixing the orientation of the eyes

The Free Transform bounding box appears.

8 Place the pointer over a handle at one of the corners.

The pointer changes to a double-headed arrow.

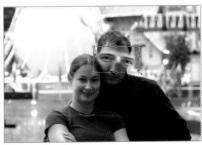

9 Hold down the Alt + Shift keys and drag the handle inward until the new set of eyes fits into the face. Press Enter.

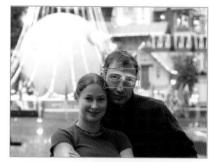

A Reducing the size of the eyes

Press Ctrl + + several times to zoom into the eyes. Select the Move Tool () from the toolbox and adjust the position of the eyes.

(1) As you can see, the eyes are much brighter than the rest of the image. Let's fix this using the Levels command. Select [Enhance]-[Adjust Brightness/Contrast]-[Levels] from the menu bar or press [Ctrl + L]. In the Levels dialog box, enter 23, 0.77, and 255 in the Input Levels text boxes, respectively. Click OK.

(12) Select the Eraser Tool (2) from the toolbox. In the options bar, set Size to 30 pixels and Opacity to 50%.

(3) Use the Eraser Tool (3) to erase as much of the skin as possible, leaving the eyes untouched.

This will minimize the difference in skin tone and make the face look more natural.

14) Press [Ctrl] + 0 to view the entire image.

(15) Select [Layer]-[Flatten Image] from the menu bar.

This combines the two layers into one.

▲ Combining the two layers

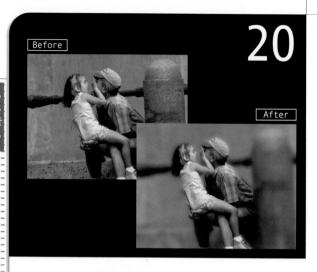

Selective Focusing

Selective focusing is the photographic technique of keeping an area of the scene in focus while the rest of the scene is blurred. This technique has the effect of focusing the viewer's attention on a particular object or area of the image. If you are not using an SLR camera, this effect can be hard to create because the scene in your viewfinder will always look sharp. With Photoshop Elements, however, you can create such effects without the need for special lenses or equipment.

1) From the menu bar, select [File]-[Open].

The Open dialog box appears.

Open the Sample\Chapter 3\Tech20.jpg file from the supplementary CD.

As you can see, the photographer has captured an intimate moment between father and child. This is a nice shot except that the background looks rather cold and drab. To fix this problem, let's blur out the background to give the image a softer feel and focus attention on the father and daughter.

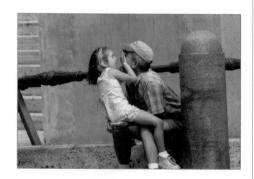

From the toolbox, select the Selection Brush Tool () and set the brush size to **35 pixels** in the options bar.

4 As shown below, drag over the subjects to select them. You may find it necessary to adjust the selection brush size as you go along.

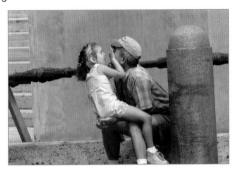

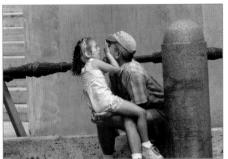

[5] If you didn't select the ribbon on the girl's dress, select the Magnifying Tool () from the toolbox and zoom in on the ribbon. Next, select the Selection Brush Tool () and set the brush size to 6 pixels in the options bar. Drag over the ribbon to select it.

6 Let's remove the gap between the two subjects from the selection. Holding down at key, drag over the gap as

shown.

On the menu bar, choose [Select]-[Save Selection] to save the selection. When the Save Selection dialog box appears, enter **People** in the Name field and click OK.

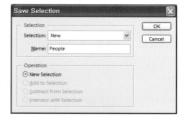

8 In the Layers palette, click and drag the Background layer to the Create a New Layer icon ().

This will create a duplicate layer in the Layers palette.

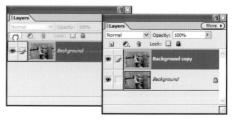

9 Press ctrl + D to deselect the two subjects. Select [Filter]-[Blur]-[Gaussian Blur] from the menu bar. In the Gaussian Blur dialog box, enter 20 in the Radius field and click OK.

10 Choose [Select]-[Load Selection] from the menu bar to use the selection border that you saved earlier. When the Load Selection dialog box appears, select **People** from the drop-down Selection menu and click OK.

On the menu bar, choose [Select]-[Modify]-[Contract]. In the Contract Selection dialog box, enter **3 pixels** in the Contract By field and click OK.

Press the pulled key to delete the blurred subjects from the duplicate layer. This will let the subjects on the background layer show through. Press Ctrl + D to deselect the two subjects.

Note that the two subjects have a soft, natural looking outline. This is the reason why the selection border had to be contracted in the previous step.

More icon (More →) at the topright corner and select [Flatten Image] from the popup menu to merge the two layers into one.

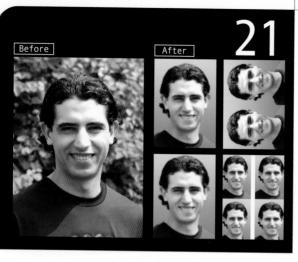

Creating a Studio Background and Picture Package

If you need a passport photo for your job application or other sorts of forms but you don't have any, you can take a good portrait shot of yourself and alter the background to make it look like a studio backdrop. With Photoshop Elements, you can even print a picture package that is a collection of the same picture in different sizes.

Select [File]-[Open] from the menu bar.

The Open dialog box appears.

Open the Sample\Chapter 3\Tech21.tif file from the supplementary CD.

It is best to take portraits indoors. Pictures taken outdoors are generally brighter, and the exposure is difficult to adjust when retouching.

③ Select the Crop Tool () from the toolbox. In the options bar, set Width to 5 cm, Height to 7 cm, and Resolution to 200 pixels/inch.

A Click and drag over the image to produce a wallet-sized picture. Press Enter to crop the picture to the specified size.

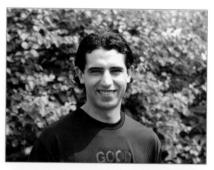

Configuring the Crop Tool's options before cropping the image will save the settings so that the same settings can be used with the Crop Tool the next time. To clear the tool settings, click the Clear button (Clear) in the options bar.

Standard Portrait Sizes	
Half Wallet Pictures	3 cm×4 cm
Passport Pictures	3.5 cm × 4.5 cm
Wallet Pictures	5 cm×7 cm

(5) Now, we will remove any blemishes from the skin. Select the Clone Stamp Tool () from the toolbox. In the options bar, set Size to 12 pixels.

6 Hold down the Alt key and click on a patch of clear skin below the right eye to make a clone. Next, release the Alt key and stamp over the spots below the right eye.

Try to create the clone from a nearby spot for a close fit in terms of lighting and skin tone.

Zoom in on the image for delicate retouching work.

7 Hold down Spacebar to activate the Hand Tool. Move the image to see the forehead. Repeat step 6 to remove the spot on the forehead.

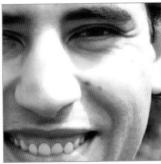

▲ Cloning a patch of skin

▲ Covering up a blemish

8 Repeat the previous steps until all the blemishes are removed from the face.

Avoid correcting large areas using the same clone patch. Make the changes progressively; change the brush size and use the Alt key to make a new clone each time.

Select the Dodge Tool () from the toolbox. In the options bar, set Size to 100 pixels.

Click and drag the tool over the face and the hair to brighten up the entire image. As the left side of the face is darker, click and drag the tool over it a few more times to match the brightness on the right side.

The Dodge Tool is useful for adjusting different areas of an image to different levels of brightness, while the Levels menu applies the same brightness to the entire image.

(1) Select [Layer]-[Duplicate Layer] from the menu bar to duplicate the Background layer. Click OK.

▲ The duplicate Background layer

Select the Smudge Tool () from the toolbox. In the options bar, set Brush to **Soft Round**, Size to **70 pixels**, and Strength to **50%**.

(3) Click on the background some distance away from the subject, and drag outward to blur the background.

▲ Smudging the background

- (4) Repeat the process to smudge the area close to the subject.
- The Smudge Tool simplifies the background by combining surrounding pixels.
- If you accidentally smudge the image of the subject, press Ctrl + Z to undo.

15 We will now select the smudged background. First, select the Magic Wand Tool () from the toolbox. In the options bar, set Tolerance to 70.

16) Click on the background to select it.

▲ Selecting the background using the Magic Wand Tool

▲ The selection

Hold down the Shift key and click on other parts of the background to add them to the selection.

▼ Include only the background in the selection.

18 If you accidentally select the model, remove the selection by holding down the Alt key and clicking. To add more of the background, click while holding down the Shift key. Repeat until all the background areas have been selected.

You should adjust the Tolerance value of the Magic Wand Tool to alter the size of the area selected (or deselected) with each click of the tool.

(19) Select [Select]-[Inverse] from the menu bar to invert the selection.

The subject is selected instead.

Select [Layer]-[New]-[Layer via copy] from the menu bar to copy the selected image onto a new layer.

▲ Creating a new layer

21 In the Layers palette, click the Indicates Layer Visibility option for all layers, except for Layer 1.

This hides all layers, except Layer 1.

▲ Only Layer 1 is visible.

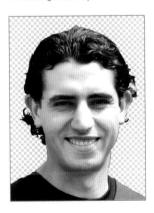

Select the Eraser Tool () from the toolbox. In the options bar, set Brush to **Hard Round** and Size to **20 pixels**.

- 23 Drag over the edges of the image to erase any remnants of the background. Make sure that the Eraser Tool is not applied to the face.
- A Select the Background copy layer from the Layers palette.

Click the Set Foreground Color icon in the toolbox. In the Color Picker dialog box, set the RGB values to 210, 240, and 180. Click OK. Next, set the RGB values for the background color to 0, 150, and 150.

Select the Gradient Tool () from the toolbox. In the options bar, select **Linear Gradient** and set Opacity to **100%**.

Click and drag in a straight line from the top to the bottom to apply the gradient.

Check that the Background copy layer is selected in the Layers palette before applying the gradient.

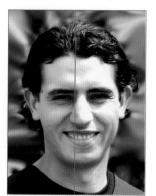

Next, we need to soften the edges of the face. Select Layer 1 from the Layers palette and click the image while holding down the cm key to select the face.

Select [Select]-[Modify]-[Contract] from the menu bar to shrink the selection border. In the Contract Selection dialog box, set Contract By to 3. Click OK.

Select [Select]-[Feather] from the menu bar. In the Feather Selection dialog box, set Feather Radius to 5. Click OK.

3) Select [Select]-[Inverse] from the menu bar to invert the contracted selection border.

▲ Inverting the selection

Select [Select]-[Filter]-[Blur]-[Gaussian Blur] from the menu bar. The Feather Selection dialog box appears. Set Radius to 3. Click OK.

This will blur the background.

33 Press cm + D to deselect. In the Layers palette, drag Layer 1 onto the Create a New Layer button to make a copy of the layer.

Select the Layer 1 copy from the Layers palette. Select [Select]-[Filter]-[Blur]-[Gaussian Blur] from the menu bar. In the Gaussian Blur dialog box, set the Radius to 3 and click OK.

This will blur the man.

35 In the Layers palette, set Opacity to 40% to soften the facial features.

▲ The final image

Next, we'll print a complete set of portraits for various uses. Select [File]-[Print Multiple Photos] from the menu bar. In the Print Photos window, select [Picture Package] from Select Type of Print, and match the Select a Layout selection shown in the screenshot to the right. Check the One Photo Per Page option to see many pages of images.

The Select a Frame menu offers a variety of different frames and borders to embellish images.

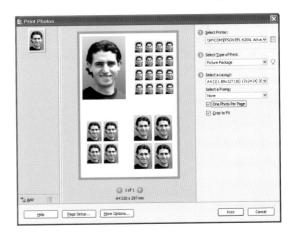

37 Clicking Print will print out the images in various sizes.

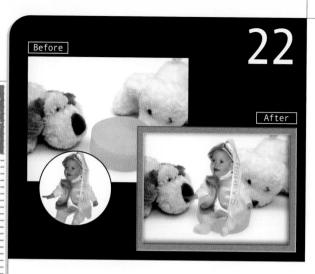

Adding a Picture Frame

In this section, you will learn to combine an image of a baby with a picture of plush toys before framing it with one of the 15 default frames found in the Effects palette. You will adjust the contrast and feather the selection edges in order to blend the images together flawlessly. As you shall see, there are many interesting frames, from brushed aluminum to spatter, that you can choose from.

- Open the Sample\Chapter 3\Tech22b.tif file from the supplementary CD.
- Select the Magic Wand Tool () from the toolbox. In the options bar, check the **Contiguous** option and set Tolerance to 15.
- 3 Click on the image to select only the white background.

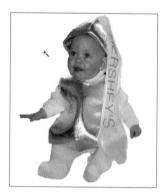

4 Press Shift + Ctrl + I to invert the selection and select the baby instead. Press Ctrl + C to make a copy of the baby.

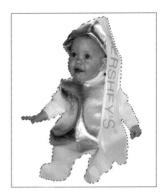

- 5 Open the Sample\Chapter 3\Tech22a.tif file from the supplementary CD.
- 6 Press cm+v to paste the copy onto the image.

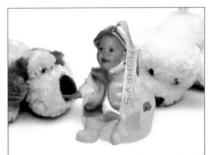

- Select [Image]-[Transform]-[Free Transform] from the menu bar or press cril+T. The Free Transform bounding box will appear over the baby's image.
- 8 Place your cursor over a corner handle until it changes to a double-headed arrow. Hold down the shift key and drag the handle outward to enlarge the image.

9 Drag the bounding box to position the baby on the yellow support. Press Enter to confirm the transformation.

O Select [Enhance]-[Adjust Brightness/Contrast]-[Levels] from the menu bar or press cm + L to adjust the contrast of the baby's image. In the Levels dialog box, enter the values 25, 1.25, and 235 in the Input Levels text boxes. Click OK.

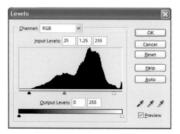

▲ The contrast in the baby's image now matches the background's.

11) In the Layers palette, hold down the cm key and click on Layer 1 to select the baby.

(2) Choose [Select]-[Feather] from the menu bar. In the Feather Selection dialog box, set Feather Radius to 10 to soften the edges around the baby's image. Click OK.

▲ Before applying Feather

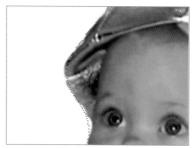

▲ After applying Feather

13 Invert the selection by pressing Shift + Ctrl + I. Press Delete to remove the border around the baby's image. Press Ctrl + D to deselect the baby.

- Glect [Window]-[Styles and Effects] from the menu bar. In the Styles and Effects palette, select **Frames** from the drop-down menu.
- (5) Click on the **Wood Frame** thumbnail. Then, click on the Apply button.
- (6) A warning box appears, asking if you wish to combine the layers into one. Click OK to create a picture frame around the image.

2...

40 Digital Photo Retouching Techniques

Editing Skills and Special Effects

In this chapter, you will learn all the essential editing skills for working with all kinds of images. For a start, you will learn to split a scan of multiple images into individual files. We'll also work with raw image files from digital cameras. Following that, you will learn to adjust image size and shape, straighten distorted images, remove elements from an image, combine images, and so on. By the end of the chapter, you will have mastered the skills and techniques necessary for most situations.

① Open the Sample\Chapter 4\Tech23.jpg file from the supplementary CD.

The image is made up of five pictures that were scanned together. Note that all of the scanned images are slanted in one way or another.

Select [Image]-[Divide Scanned Photos] from the menu bar to split up the five images into individual image files.

In the Photo Bin, you can see that the scanned images have been split into individual image files. If the Photo Bin is not open, click the Toggle Photo Bin button (() at the bottom of the window.

Automatically Separate Scanned Images

Photoshop Elements 3.0 has the wonderful new Divide Scanned Photos command, which will save you a lot of time in scanning pictures and straightening scanned images. Instead of scanning and straightening pictures one at a time, you can scan a few pictures at one go and then select the Divide Scanned Photos command to split the scanned image into individual image files. Photoshop Elements will automatically crop and straighten the images. It takes only one click!

Opening and Processing a Camera Raw Image File

Photoshop Elements 3.0 contains a new plug-in for editing raw (uncompressed) digital photos. This new feature is useful for photographers who use mid- to high-end camera models that record images in the RAW format. Beginners should note that entry-level cameras store files of various resolutions using the JPEG format—not RAW. Regardless of the camera that you use, you will learn to open and process a RAW image file using the provided sample file.

Why Use Camera Raw?

Professional photographers prefer to work in the RAW format because raw files, unlike JPEG files, receive almost no processing in the camera. A raw file records an image as it was taken, without the camera automatically sharpening or adjusting the white balance, for instance. This gives the photographer greater control over the image.

Another important difference is that raw files are stored in 12-bit mode, while JPEG files are only 8-bit. This essentially means that raw files are of a much higher quality than JPEG files. With the superior quality of raw images, you can do more extensive editing in Photoshop Elements because there is more data to work with. With JPEG files, you cannot edit the image as freely because an extended editing process can seriously degrade the image quality.

1 Open the Sample\Chapter 4\Tech24.CRW file from the supplementary CD.

The file will not open directly in Photoshop Elements' image window. Instead, the file will appear in the Camera Raw dialog box which opens immediately after step 1. The title bar of the dialog box contains information on the image, such as the make and model of the camera used to capture the image and the settings or conditions under which the image was taken.

The image still looks a little dull. Let's increase the contrast. Set the Shadows to **20** and the Brightness to **80**. You can see in the preview window that the image appears sharper than before.

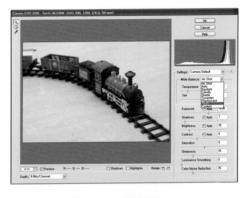

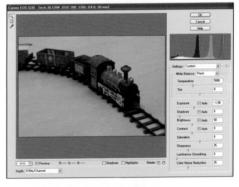

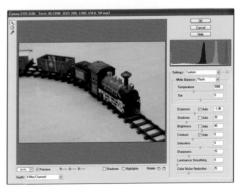

(5) Click OK. The modified image will open in Photoshop Elements' image window. You can then edit the file as you would any other.

6 When you are done editing, select [File]-[Save As] from the menu bar to save the image as a JPEG or TIFF file.

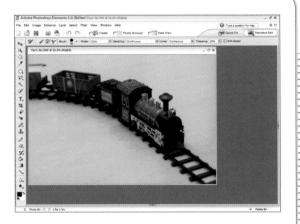

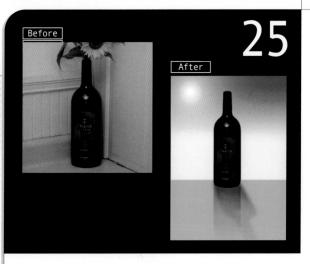

Adjusting Image Size and Shape

In this example, you will learn how to transform an ordinary product shot by using the Free Transform Tool to rotate, resize, and warp a copy of the image to add shadows. You will also use the Gradient Tool to create a background that has gradations in color and the Lens Flare filter to add a sparkle to the composition.

- 1 Open the Sample\Chapter 4\Tech25.tif file from the supplementary CD.
- ② Select the Polygonal Lasso Tool () from the toolbox. Repeatedly click and drag along the bottle's shape to select it. When you have almost outlined the entire bottle, click on the point where you started to close the selection.

3 Double-click on the Background layer in the Layers palette to open the New Layer dialog box. The default Name is **Layer 0**. Click OK to change the Background layer into a regular layer.

- 4 Choose [Select]-[Inverse] from the menu bar to select the area around the bottle instead. Press Delete to remove the background.
- 5 Press Ctrl+D to deselect.
- If you do not change the Background layer into a regular layer before deleting the selection, the deleted portion of the image will take the background color and will not be transparent.
- 6 Select [Image]-[Resize]-[Canvas Size] from the menu bar. In the Canvas Size dialog box, click the top-center square in the Anchor grid. This will anchor the existing image to the top-center position of the canvas. Set the Height to 20 cm. Click OK.

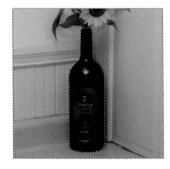

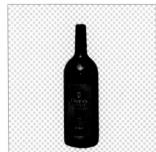

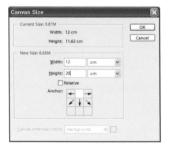

Click and drag Layer 0 onto the Create a New Layer icon () in the Layers palette. This will create a Layer 0 copy layer above Layer 0.

8 Select [Image]-[Transform]-[Free Transform] from the menu bar. The Free Transform bounding box appears around the bottle. In the options bar, set the angle to 180° to flip the bottle upside down.

You can also rotate the image with your mouse. After the bounding box appears, move your pointer near one of the corner handles until you see the pointer turn into . Then click and drag the corner to rotate the image.

(9) Click and drag the rotated image downward so that its base lines up with the bottom of the original image.

A better way of creating a reflection is to use the [Image]-[Rotate]-[Flip Layer Vertical] command from the menu bar. This will flip the image so that it looks exactly like a reflection of the original bottle. Although rotating the bottle is more troublesome and does not create an accurate reflection (the left side of the bottle is reflected on the right side), I want to get you familiar with the Free Transform Tool before moving on to other techniques.

Move the pointer to the lower-middle handle of the reflection. The pointer changes to . Click and drag the bounding box downward to make it longer. Hit _Enter_.

11 In the Layers palette, move Layer 0 copy below Layer 0. Click the Create a New Layer icon () in the Layers palette to create a new layer. The new Layer 1 is created above Layer 0 copy.

(2) Click and drag Layer 1 right to the bottom of the layers. Next, select the Rectangular Marquee Tool ((2)) from the toolbox. Select the reflection, as shown.

(3) Click the Set Foreground Color icon in the toolbox. In the Color Picker dialog box, set the RGB values to **140**, **200**, and **200**. Click OK to change the foreground color.

Select [Edit]-[Fill Selection] from the menu bar. In the Fill dialog box, set Use to **Foreground Color**. Click OK. Press cm+D to deselect the selection.

(15) Click the Create a New Layer icon () in the Layers palette to create a new layer. Click and drag the new Layer 2 below Layer 1.

Repeat steps 13 and 14 for Layer 2, using the RGB values 255, 255, and 200, respectively.

[Filter]-[Blur]-[Motion Blur] from the menu bar to blur the reflection. In the Motion Blur dialog box, set Angle to 90° and Distance to 250 pixels. Click OK.

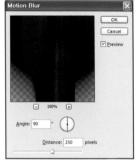

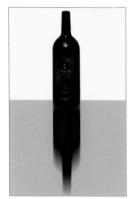

18 In the Layers palette, set the Opacity of Layer 0 copy to 50% to lighten the reflection.

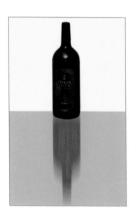

19 Select the Eraser Tool () from the toolbox. In the options bar, set Brush to **Soft Round**, Size to **500 pixels**, and Opacity to **50%**. Click and drag over the reflection so that it gets fainter toward the bottom.

20 In the Layers palette, click and drag Layer 0 onto the Create a New Layer icon () to create a copy. Click and drag Layer 0 copy 2 below Layer 0.

(21) Select Layer 0 copy 2. Select [Image]-[Transform]-[Free Transform] from the menu bar or press Ctd+T. In the options bar, set Angle to -180° to rotate the bottle.

22 Drag the reflection downward so that its base lines up with the bottom of the bottle.

23 Hold down the cm key and drag a lower-corner handle sideways. Repeat the step on the other corner until you get the result as shown. Press Enter.

Select the Move Tool () from the toolbox. Move the warped reflection so that its base lines up with the bottle.

25 Select [Filter]-[Blur]-[Gaussian Blur] from the menu bar. In the Gaussian Blur dialog box, set Radius to **15 pix-els**. Click OK to blur the reflection.

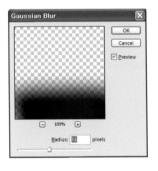

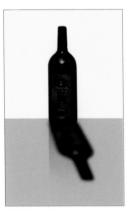

26 Select Layer 0 copy 2. Select the Eraser Tool (2). In the options bar, set Brush to **Soft Round**, Size to **500 pixels**, and Opacity to **50%**. Drag over the reflection such that it gets fainter toward the bottom.

Click the Set Foreground Color icon in the toolbox. In the Color Picker dialog box, set the RGB values to **160**, **90**, and **0**. Click OK to change the foreground color.

Select Layer 2. Select the Gradient Tool () from the toolbox. In the options bar, click on the Gradient Picker arrow to see thumbnails of available gradients. Select the Foreground to Transparent gradient.

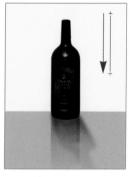

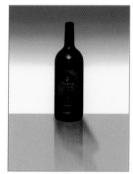

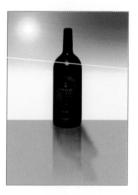

Cleaning Up Backgrounds

It is inevitable that unwanted people or objects will sometimes appear in the background of your pictures. This will ruin the composition of your shot and also detract attention from your main subject. A good way to solve this problem is to use the Clone Stamp Tool, which can stamp out unwanted objects easily. In this exercise, you'll use this tool to clean up a background to better isolate a photo's main subject. We'll also cover using such tools in a perfectly straight line so that you can edit images with great precision.

1) Open the Sample\Chapter 4\Tech26.jpg file from the supplementary CD.

You will be removing the foot path in the background.

Choose the Clone Stamp Tool () from the toolbox. In the options bar, set the Size to **50 pixels**, Mode to **Normal**, and the Opacity to **100**%.

3 Holding down the Alt key, click on a patch of grass above the foot path to create a clone.

4) Release the Alt key and drag over the foot path to cover it up with the grass patch. If you drag too far right, you will start seeing the child's image repeated in the clone. This is because the tool starts duplicating the image from the point you created the clone. If the child's image appears in the clone, undo the step, drag in short distances, and remember to keep cloning between drags.

(5) As in step 4, hold down the Alt key and create a clone from above the foot path on the right side of the picture. Then, release the Alt key and drag the tool over the path on the right side. Again, be careful not to drag too far without taking another clone sample.

(6) With the Zoom Tool () selected, click on the image to zoom in on the child's head. Select the Clone Stamp Tool () and set the Size to 30 pixels in the options bar. Hold down the Alt key and use the Clone Stamp Tool to make a new clone.

7 Release the Alt key and stamp over the footpath on the left.

8 Repeat the previous step on the footpath on the right.

Press ctrl+0 to fit the entire image in the work-space.

Using the Shift Key for Straight Lines

If the object that you are trying to remove has a rather straight outline, like the smokestacks in the following example, you can use the shift key together with the Clone Stamp Tool to remove it easily.

With the Clone Stamp Tool selected, simply hold down the Shift key and click on one end of the object. Then hold down the Shift key again and click on the other end. The Clone Stamp Tool will remove the area in-between in a straight line.

The following example can be found on the supplementary CD-ROM: Sample\Chapter 4\Tech26-1.tif.

Set the Size of the Clone Stamp Tool to **200 pixels**. Hold down the shift key and click on the tip of the smokestack.

2 Hold down the Shift key and click on the smokestack's base.

3 The Clone Stamp Tool applies the clone in a straight line between the starting and ending points.

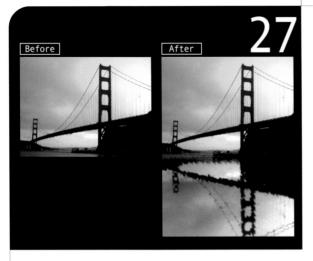

Creating Reflections

When combining images, you may have to create a new reflection for the objects that you've altered in your images. Obviously, this is necessary only if there is a reflective element in your new composition. Even if you are not combining images, you may also want to create or retouch the reflections in your images to enhance the visual effect. In this example, my camera lens was not wide enough to take in the entire scene, so I added the reflection later in Photoshop Elements.

- 1 Open the Sample\Chapter 4\Tech27.tif file from the supplementary CD.
- 2 Select [Image]-[Resize]-[Canvas Size] from the menu bar. In the Canvas Size dialog box, click on the top-center square on the Anchor grid. This will anchor the image to the top-center position of the canvas. Increase the Height to **20 cm**. Click OK.

3 Select the Rectangular Marquee Tool () from the toolbox. Select the image, as shown here.

The extra space added to the canvas will take on the background color indicated at the bottom of the toolbox. For this exercise, use a white background color.

(4) Select [Layer]-[New]-[Layer via Copy] from the menu bar to create a copy of the selection on a new layer. In the Layers palette, you can see that a new layer is created for the copy.

(5) Select [Image]-[Rotate]-[Flip Layer Vertical] from the menu bar to flip the copy vertically.

- Select the Move Tool () from the toolbox.
- Drag the copy to the bottom of the original image to use it as the reflection.

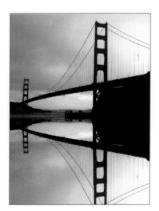

- 8 Select [Filter]-[Distort]-[Ripple] from the menu bar. In the Ripple dialog box, set Amount to **310**%. Click OK.
- Select [Filter]-[Blur]-[Gaussian Blur] from the menu bar. In the Gaussian Blur dialog box, set Radius to 2 pixels to blur the image slightly. This will make the reflection look more realistic. Click OK.

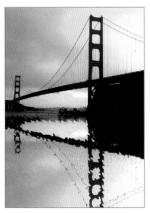

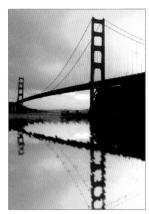

▲ Ripple

▲ Gaussian blur

① Select the Burn Tool () from the toolbox. In the options bar, set Brush to **Soft Round**, Size to **250 pixels**, Range to **Midtones**, and Exposure to **50%**.

11) Drag over the reflection to make it darker.

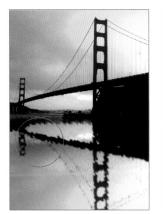

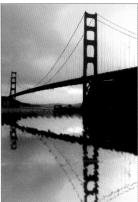

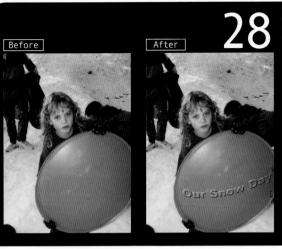

In this section, you will learn to enhance the visual appeal of text on images by using a series of blending, warping, and embossing techniques. In this exercise, we will emboss a word onto a curved surface to make it look like it is actually part of the surface.

- Open the Sample\Chapter 4\Tech28.jpg file from the supplementary CD.
- Select the Horizontal Type Tool (T) from the toolbox. In the options bar, set Font to Arial Black, Size to 60 points, and Color to Black.

- (3) Click on the orange sled in the picture, and type in the words Our Snow Day.
- 4 Select [Layer]-[Type]-[Warp Text] from the menu bar. In the Warp Text dialog box, set the Style to Arc , Bend to -22%, Horizontal Distortion to 0%, and Vertical Distortion to -5%. Click OK.

5 Press cm+T to activate the Free Transform command. When the bounding box appears, move the pointer near one of the corner handles. When the pointer changes to , click and drag the box until it fits the shape of the sled. Hit Enter.

6 Select [Window]-[Styles and Effects] from the menu bar. When the Styles and Effects palette appears, select **Text Effects** and double-click on the **Clear Emboss** effect, which will make the text looks as if it is protruding from the sled. Click Apply.

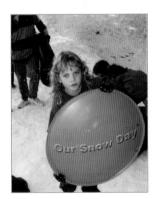

Fine-Tuning the Effects Applied

You can fine-tune the effects you have already applied by double-clicking the symbol next to the layer to which the effects were applied. This opens up the Style Settings dialog box from which you can adjust factors such as the lighting angle, bevel size, and direction.

You can also select [Layer]-[Layer Style]-[Style Settings] from the menu bar to open the Style Settings dialog box.

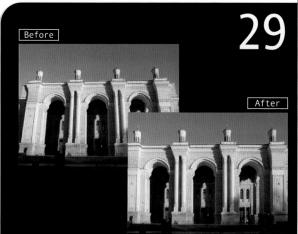

Altering Perspective

When a tall or wide structure is shot from the ground up, the structure seems to converge towards the sky. The only way to shoot such a picture without distortion is to take your shot from a location at half the height of the structure. You would also need to stand far enough away to fit the entire structure in the frame. Thankfully, although it is hard to get shots of giant structures without distortion, you can fix the distortion easily using the Distort command in Photoshop Elements.

- Open the Sample\Chapter 4\Tech29.jpg file from the supplementary CD.
- (2) Hit the cm+R keys to display rulers to the left and on top of the image. Another way to display the rulers is to choose [View]-[Ruler] from the menu bar.

These rulers will serve as good visual aids when you are straightening the building.

Changing the Unit of Measurement

By default, the rulers are set to measure in centimeters (cm), but the unit of measurement can be changed. To do so, select [Edit]-[Preferences]-[Units & Rulers] from the menu bar and, when the Preferences dialog box appears, click on the Rulers drop-down menu to choose a unit of measurement from the list.

3 Select [View]-[Grids] from the menu bar. A grid will appear over the image. The grid and the rulers are visual aids that will not print with the image.

4 Press Ctrl+ to zoom out of the image.

- 5 Select [Image]-[Transform]-[Distort] from the menu bar. You'll see a dialog box asking if you want to change the Background layer to a normal layer. Click OK.
- 6 When the New Layer dialog box appear, type in a name for the layer or leave the name as Layer 0. Click OK.

- 7 When the image's bounding box appears, drag the top-right handle of the bounding box to the right to straighten the building.
- 8 Drag the top-left handle of the bounding box to the left and slightly upwards.
- After straightening the building, you will notice that the building appears shorter than it did originally. Drag the top-middle handle upwards to correct this problem. Hit the Enter key to activate the transformation.

Choose [View]-[Grids] from the menu bar to remove the grid and hit the Ctrl+R keys to hide the rulers.

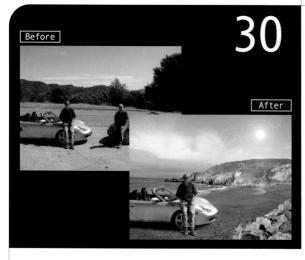

Combining Images

One of the easiest ways to create new and exciting compositions is to combine individual pictures. In this section, you will learn to combine images inconspicuously by cleaning up the edges of pasted objects and adjusting the brightness and contrast so that elements taken from different sources blend together.

- 1 Open the Sample\Chapter 4\Tech30a.tif file from the supplementary CD.
- 2 Select the Zoom Tool () from the toolbox. Select the man on the left to zoom in on him.

3 Select the Selection Brush Tool () from the toolbox. In the options bar, set Size to **35 pixels**, Mode to **Mask**, Hardness to **0%**, Overlay Opacity to **50%**, and Overlay Color to **Red**.

A Hardness of 0% makes the brush edges soft and natural. This is important in making the selection border less obvious when the image is placed into another picture.

Paint over the man, the silver car, and their shadows to create a mask. Change your brush size as you go along in order to cover the desired area accurately.

(5) In the options bar, set the Mode to **Selection**. This will select the unmasked area.

6 Choose [Select]-[Inverse] from the menu bar to invert the selection and select the masked area instead. Press cm+c to copy the selection.

Open the Sample\Chapter 4\Tech30b.tif file from the supplementary CD.

8 Press cm+v to paste the image of the man and his car onto the image of the beach.

9 Select the Move Tool () from the toolbox. Drag the man and his car to the position shown.

10 Select the Zoom Tool () from the toolbox. Select the car to zoom in on it.

Select the Eraser Tool () from the toolbox. In the options bar, set the Brush to **Soft Round** and Size to **9 pixels**. Use the Eraser Tool to clean up the edges of the pasted image.

(12) In the options bar, set Size to **50 pixels** and Opacity to **50%**. Use the Eraser Tool to clean up the edges of the car's shadow.

(3) Let's adjust the brightness and contrast of the pasted image to match the background's. Select [Enhance]-[Adjust Brightness/ Contrast]-[Brightness/Contrast] from the menu bar. In the Brightness/Contrast dialog box, set Brightness to 5 and Contrast to 10. Click OK.

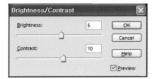

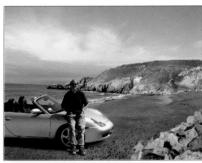

(14) Click the More button in the Layers palette. Select [Flatten Image] from the drop-down menu to combine the two images on one layer.

15 Select [Filter]-[Render]-[Lens Flare] from the menu bar. In the Lens Flare dialog box, click in the Flare Center window to position the lens flare. Set Brightness to 100%. Click OK.

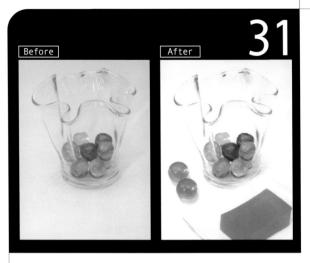

Combining Product Pictures

Product shots are some of the most popular assignments for professional photographers. If after a product shoot, you find that you are dissatisfied with the composition of the shots you took, you can consider combining several individual product shots on a single page for the result you want. Sometimes you need to do this because there is neither time nor opportunity to reshoot the pictures.

- 1 Open the Sample\Chapter 4\Tech31a.tif file from the supplementary CD.
- 2 Select [Enhance]-[Adjust Brightness/Contrast]-[Brightness/Contrast] from the menu bar. In the Brightness/Contrast dialog box, set Brightness to +15 and Contrast to +25. Click OK. This will make the image brighter.

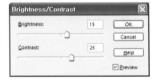

3 Double-click on the Background layer in the Layers palette. When the New Layer dialog box appears, you will see that the default file name is Layer 0. Click OK. The Background layer will be turned into an ordinary layer.

- Open the Sample\Chapter 4\Tech31b.tif file from the supplementary CD.
- (5) Select the Move Tool () from the toolbox. Drag the bar soap image over to the bubble soap image, as shown.

- Close the bar soap file. In the bubble soap window, drag the soap dish below the container, as shown.
- Select the Eraser Tool () from the toolbox. In the options bar, set Size to 150 pixels and Opacity to 100%. Erase the area around the soap dish, as shown.

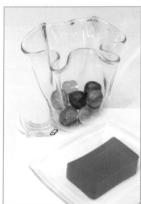

- (8) Open the Sample\Chapter 4\Tech31c.tif file from the supplementary CD.
- Select the Elliptical Marquee Tool () from the toolbox. Click and drag over a bubble soap to select it.

10 Click on the Add To Selection icon () on the options bar. Select another bubble soap to add it to the selection.

1 Select the Move Tool () from the toolbox. Drag the bubble soap over to the main image, as shown. The bubble soap will be added on the new Layer 2.

(12) Close the **Tech31c.tif** file. In the Layers palette, drag Layer 2 onto the Create a New Layer icon () to make a copy of the bubble soap.

13 Move Layer 2 copy below Layer 2.

A Select [Filter]-[Blur]-[Gaussian Blur] from the menu bar. In the Gaussian Blur dialog box, set Radius to 5 pixels. Click OK to blur the edges of the bubble soap slightly.

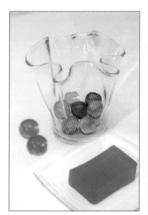

15 In the Layers palette, set Opacity for Layer 2 copy to 70%. We will use this image as the shadow for the bubble soap.

16 Select the Move Tool () from the toolbox. Press the 1 and 1 keys on the keyboard several times to move the shadow to the lower right of the bubble soap.

Select [Enhance]-[Adjust Brightness/Contrast]-[Levels] from the menu bar. In the Levels dialog box, enter **0**, **1.5**, and **255** in the Input Levels text boxes to brighten up the shadow, as shown. Click OK.

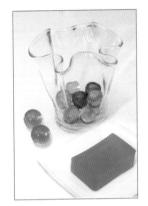

18 Select Layer 2 from the Layers palette. Select [Filter]-[Blur]-[Gaussian Blur] from the menu bar. In the Gaussian Blur dialog box, set Radius to **1 pixel**. Click OK. The blurring will blend the edges of the bubble soap into the background.

Press cm+0 to see the entire image. Check that the brightness and contrast is even throughout. If it is not, make adjustments using the [Enhance]-[Adjust Brightness/Contrast]-[Levels] or [Enhance]-[Adjust Brightness/Contrast]-[Brightness/Contrast] commands.

40 Digital Photo Retouching Techniques

Very Special Effects

One feature that instantly attracts many beginners to Photoshop Elements is the Filter command. As you discovered in the previous chapters, you can create dozens, if not hundreds, of snazzy effects with this command.

In this chapter, you will explore filters further and learn to make practical and creative use of filters together with other commands. The examples I am about to show you are wide and varied. You will learn to imitate photography techniques such as stitching together images to create a panorama, simulating motion blur, enhancing landscape pictures by making it snow, utilizing the Define Pattern command, and much much more.

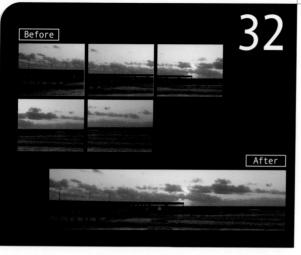

Stitching Panoramas

It is difficult to capture the wide expanse of a landscape in a single picture. If you stand some distance away in order to get everything in, the elements of the scene will appear too small. If you stand too close, the reverse happens. For such scenes, it is better to capture sections of the landscape in a few shots and then merge them together in Photoshop Elements.

- Select [File]-[New]-[Photomerge Panorama] from the menu bar. In the Photomerge dialog box, click Browse.
- (2) When the Open dialog box appears, open the Sample\
 Chapter 5\panorama folder on the supplementary CD. Hold down the Shift key and select all the pictures in the folder.
- 3 Click Open. The files will appear in the Source Files window in the Photomerge dialog box.

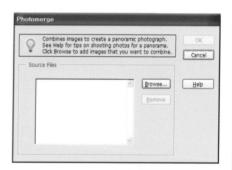

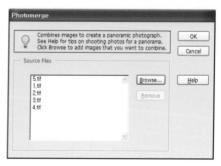

4 Click OK to open the files and execute the Photomerge command. The program will automatically analyze the image data of the overlapping areas and merge the pictures into a panorama. Note that the center piece is in the wrong position.

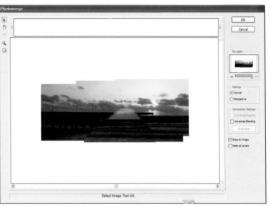

5 Click on the Select Image Tool (1) in the Photomerge dialog box. Click and drag the center image to the right.

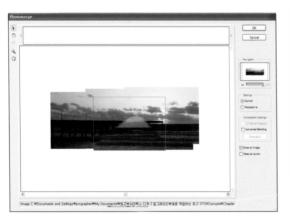

6 Check the Advanced Blending option under Composition Settings at the right of the Photomerge dialog box to blend the edges of the pictures. Click Preview.

Click OK to complete the photomerge. The panorama appears in a new window.

Select the Crop Tool () from the toolbox. Select the image as shown, leaving out the jagged edges. Press Enter

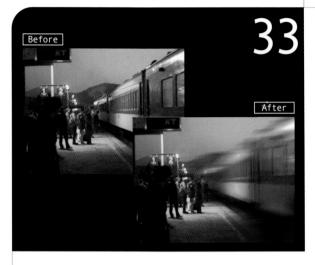

Adding Motion Blur

The Motion Blur filter in Photoshop Elements is great for adding motion to pictures of movable objects. It is commonly used on images of vehicles such as cars and trains. You can also use it on a shot of people walking or even on a shot of a fan.

- Open the Sample\Chapter 5\Tech33.tif file from the supplementary CD.
- (2) In the Layers palette, click and drag the Background layer onto the Create a New Layer button () to make a copy of the layer. In the following steps, we will be adding motion blur effects to the copy and overlaying it onto the background.

- (3) Select [Filter]-[Blur]-[Motion Blur] from the menu bar. In the Motion Blur dialog box, set Angle to 5° and Distance to 100 pixels. Click OK.
- Angle refers to the direction in which the motion blur will be applied. An angle of 0° applies the motion blur horizontally and an angle of 90°, vertically. In this example, an angle of 5° applies the motion blur at a slight angle from the x-axis. Distance refers to how far the motion blur is applied.

(4) Select the Eraser Tool ([2]) from the toolbox. In the options bar, set Size to 300 pixels. Erase everything in the picture but the train. This allows the background to show through areas that we want to keep in focus.

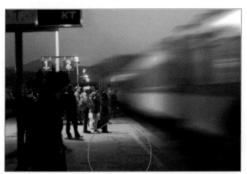

In the options bar, set Opacity to 30%. Drag over the front portion of the train to reduce the motion blur. This gives the image an illusion of depth.

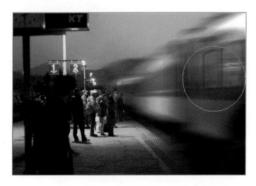

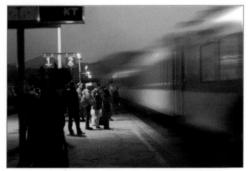

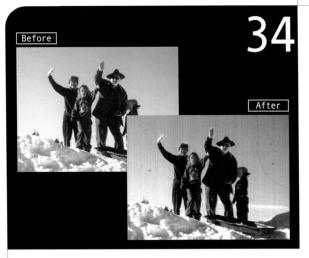

Giving Photos an Antiqued Look

Old photographs evoke nostalgia and seem more precious because of their fragility and the fact that the memories they capture are of a distant past. You can imitate the faded look of antiquated photos in your images by adding graininess, desaturating the colors, and adding hair and dust particles. Of course, Photoshop Elements allows you to implement and blend these effects for that perfectly aged look.

1 Open the Sample\Chapter 5\Tech34.jpg file from the supplementary CD.

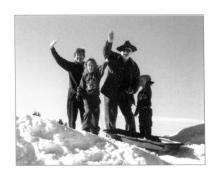

2 Select [Filter]-[Texture]-[Grain] from the menu bar. In the Grain dialog box, set Intensity to 12, Contrast to 13, and Grain Type to Vertical. Click OK to add fine vertical lines and a grainy texture to the picture. This will make the family portrait look as if it was shot with an old camera.

If you want to add horizontal lines instead of vertical ones, set Grain Type to Horizontal in the Grain dialog box.

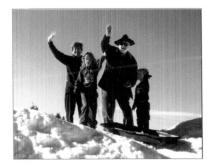

3 Select [Enhance]-[Adjust Color]-[Adjust Hue/Saturation] from the menu bar. In the Hue/Saturation dialog box, set Edit to **Master**, Hue to **-20**, Saturation to **-50**, and Lightness to **0**. Click OK. This will make the colors look faded.

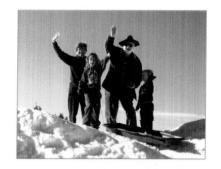

A Select [Window]-[Styles and Effects] from the menu bar. When the Styles and Effects palette appears, double-click on the Vertical Color Fade effect. The colors in the family portrait will fade toward the top.

You can make the color fade across a picture by selecting the Horizontal Color Fade icon in the Styles and Effects palette.

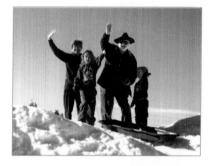

5 Open the Sample\Chapter 5\Tech34a.jpg file from the supplementary CD. This image was created by scanning the hair and dust particles placed on a scanner.

6 Press Ctrl+A to select the entire image and then press Ctrl+C to copy it.

Return to the family portrait and press cm+v to paste the dust copy onto it.

8 Press Ctrl+T and expand the dust image to fit the size of the picture. Press Enter or double-click inside the image when you are done.

9 In the Layers palette, change the blending mode of Layer 1 to **Multiply**. This will allow the family portrait to show through the dust copy.

Maintaining Texture While Repainting an Object

The key to keeping an object's texture intact when repainting it is the effective use of blending modes. When an image or pattern is pasted onto an object, the object will look flat and unnatural. In this exercise, you will learn to paste a flower pattern onto a car, then utilize blending modes to retain the car's original metallic texture.

Open the Sample\Chapter 5\Tech35a.jpg and Sample\Chapter 5\Tech35b.jpg files from the supplementary CD.

Select [Window]-[Tech35b.jpg] from the menu bar to bring forward the flower image. Choose [Select]-[All] from the menu bar to select the entire image. Next, select [Edit]-[Copy] from the menu bar or press Ctrl+C to copy the flower image to the clipboard.

3 Select [Window]-[Tech35a.jpg] from the menu bar to bring forward the car image. Select the Magic Wand Tool () from the toolbox and set the Tolerance value to 30. Click on the hood of the car, as shown here.

4 Click on the rest of the car's yellow body while holding down the Shift key to add to the selection.

Check that you have selected the car's entire yellow body, including the yellow bit on the back wheel.

6 Click on the Create a New Layer icon () in the Layers palette to create a new layer.

(7) Let's paste the flower image which was copied to the clipboard in step 2 onto the car's yellow body. Select [Edit]-[Paste Into Selection] from the menu bar.

8 You can see that the car's plain, yellow body has been replaced with the flower image.

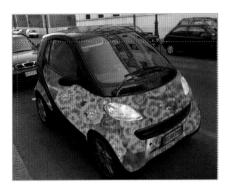

9 You may notice that the car's body now looks flat. The flower image does not have the highlights and shadows that define the car's original body. To make the body look more three-dimensional, change the blending mode to **Overlay** in the Layers palette.

10 Changing the blending mode to Overlay blends together the car's yellow body with the flower image to create a more realistic looking car body.

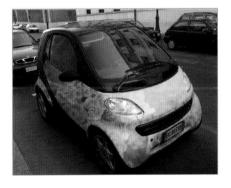

11) You can experiment with the different blending modes in the Layers palette to create a variety of new styles for the car body.

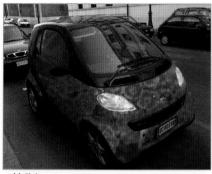

▲ Multiply

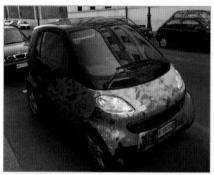

▲ Color Burn

▲ Soft Light

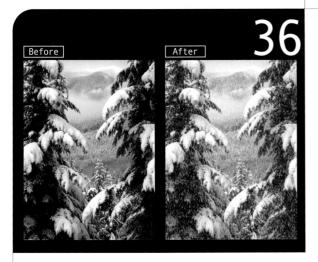

Let It Snow

Taking pictures in subzero temperatures is hard, but getting a shot with just the right amount of snowfall is even more difficult. You need perseverance and luck to get those kinds of shots. In this section, you will make a picture of snow-capped trees and mountains even more perfect by adding a snowfall with the Add Noise filter.

- 1 Open the Sample\Chapter 5\Tech36.tif file from the supplementary CD.
- 2 Click the Create a New Layer icon () in the Layers palette to create a new layer for the snow effect.
- 3 Select the Rectangular Marquee Tool () from the toolbox. Make the selection, as shown here.

(4) Click on the Set Background Color icon in the toolbox and set the background color to black. Select [Edit]-[Fill] from the menu bar. In the Fill dialog box, set Use to Background Color. Click OK to fill the selection with black.

Select [Filter]-[Noise]-[Add Noise] from the menu bar. In the Add Noise dialog box, set Amount to 40% and Distribution to Gaussian, then click the Monochromatic checkbox to create the effect in black-and-white. Click OK.

The white noise added to the picture looks like falling snow. You can increase the volume of snow by increasing the Amount in the Add Noise dialog box. Do not apply too much because it will look unnatural.

Select [Image]-[Transform]-[Free Transform] from the menu bar. A bounding box will appear around the snowflakes. Click and drag the corner handles of the bounding box so that its height fits the image's, but its width is shortened slightly. Press Enter to apply the changes

Adjusting the height of the selection elongates the snowflakes which would appear round otherwise.

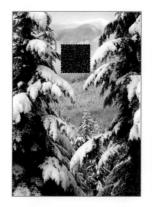

Select [Edit]-[Define Pattern from Selection] from the menu bar to save the snowflakes as a pattern. In the Pattern Name dialog box, type in Snow for Name. Click OK.

You should save a pattern if you intend to apply it repeatedly.

- 8 Press cm + D to deselect the selection. Select [Edit]-[Fill] from the menu bar. In the Fill dialog box, set Use to **Pattern**. Click the Custom Pattern icon to open the Pattern Picker. Choose the Snow pattern.
- Olick OK to apply the snow pattern to the entire image.

10 In the Layers palette, set the blending mode to **Screen** to let the background image show through.

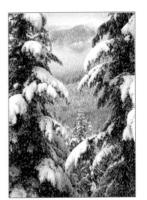

Creating Snow Using the Effects Palette
Although it is easier to create snow using the Effects
palette, you cannot adjust the shape or amount of snow
with this method. To try it out, select [Window]-[Styles
and Effects] from the menu bar to open the Effects palette.
Then select Blizzard and click Apply.

3...

40 Digital Photo Retouching Techniques

Using and Sharing Images

In this chapter, we'll create postcards, multimedia slide shows, Web banners, and Web photo galleries. While it may seem daunting to create multimedia slide shows and Web photo galleries, it really isn't; the Creations Wizard automates so many of the steps that the process is almost like shopping.

Before

Making a Postcard

Photoshop Elements makes it simple to personalize and share images in a variety of commonly seen formats, such as postcards, slides, VCD and DVD slide shows, photo albums, calendars, and Web photo galleries. In this exercise, you will learn how easy it is to create and email a postcard using the Creation Setup dialog box.

Click on the Photo Browser button (Photo Browser) in the shortcuts bar. Photoshop Elements will start loading the Organizer workspace.

Greetings from Switzerland! We're having a

areat time but we miss everyone back home tool

Love, Jane & Paul

Hello!

- Select [File]-[Get Photos]-[From Files and Folders] from the menu bar. When the From Files and Folders dialog box appears, look for the Sample\Chapter 6\Tech37a.jpg file on the supplementary CD. Select the file and click the Get Photos button (Get Photos).
- 3 In the Organizer workspace, look for the image's thumbnail in the main window. If you find it hard to locate the image, select Import Batch from the Sort menu at the bottom-left corner of the workspace.

After

4 Select the image's thumbnail and click on the Single Photo View button () in the bottom-right corner of the main window. The main window will show only the selected image.

5 Right-click in the main window and select Auto Smart Fix from the pop-up menu.

6 Now that the image has been fixed, click on the Create button (in the shortcuts bar. When the Creation Setup dialog box appears, select Postcard from the left menu and click OK.

The Creation Setup dialog box will guide you step-by-step through creating a postcard. For step 1, let's choose the **On the Road** postcard style from the menu on the right. Click Next Step >.

8 Since you are creating a postcard, there isn't any arranging to do with one image. So for step 2, click Next Step >. Step 2 is useful when you are creating photo books and album pages and need to arrange the images on the pages.

9 You will see a preview of the postcard in step 3. Double-click on the Double-Click to Insert Title text field on the postcard. When the Title dialog box opens, type in **Hello!**, set the Font to **Viner Hand ITC**, the Font Size to **36 pt**, and the Font Color to **pink**. Click Done.

Olick and drag a handle of the Hello! bounding box outwards to display the text. Next, position your pointer inside the Hello! bounding box until a hand pointer appears. Click and drag the Hello! text to the top-left corner of the postcard, as shown.

- 11 In the same way, double-click on the Double-Click to Insert Greeting field on the postcard. Enter the text and settings as shown or create your own. Click Done.
- Click on the Add Text... button in the top-left corner of the dialog box to add another text field. Use the text and settings as shown or create or your own. Click Done.

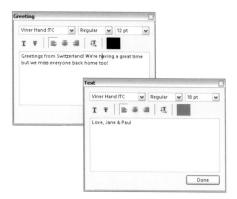

Resize and reposition the image and the text fields to create the postcard, as shown. When you are done, click Next Step >.

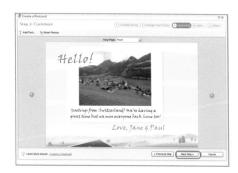

14) For step 14, enter a name for the postcard and click Save >.

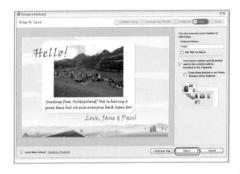

- 15 For step 15, choose one of the options for sharing your postcard. To email the postcard as a PDF document, click on the Email... button.
- You can click < Previous Step to change the postcard at any of the stages.

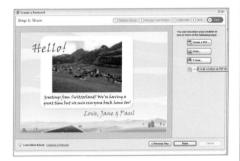

(16) When the Attach Creation Items to E-mail dialog box appears, click Add Recipient, enter a message, and click OK. If Microsoft Outlook is set as the default email client for both Photoshop Elements and your operating system, Microsoft Outlook will launch automatically and all you need to do is to click Send to email the postcard. See the note on the following page for more information on setting up email client software.

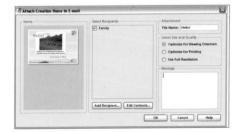

To edit the postcard after you have saved the file, look for the postcard's thumbnail in the Photo Browser, right-click on the thumbnail, and select Edit from the pop-up menu.

Setting Up an Email Client

Postcards and other creations can be sent using email clients other than Microsoft Outlook. To do so, close the Organizer workspace. In the Editor window, select [Edit]-[Preferences]-[Organize & Share] from the menu bar. In the Preferences dialog box, select the E-mail option from the left and open the E-mail Client drop-down menu, as shown.

You can set the default email client to Microsoft Outlook, Outlook Express, or the Adobe E-mail Service. Another option is to save the file you wish to send to your hard drive, then simply attach it to an email. If you choose Microsoft Outlook or Outlook Express, you should ensure that the chosen email client is the default for your computer's operating system. Windows users can check by choosing [Control Panel]-[Internet Options] from the Start menu on your computer desktop and selecting the Programs tab. For Mac users, Microsoft Entourage will become your default client automatically when you install the program.

You can also email your creations using Adobe's E-mail Service. The email service lets you send the file from Photoshop Elements itself, but you will have to specify a valid email address as the return address. This is because an email containing a code for activating this service will be sent to the return address. Adobe's E-mail Service is useful if you are using a Web-based email account.

Making a Slide Show

You don't have to be a computer expert to create a slide show with Photoshop Elements 3.0. Using Photoshop's Creations Wizard, you can create a slide show with music, transition effects, and captions. In this exercise, you will learn to create a slide show and to export the slide show as a WMV file.

- 1 Move the Slide folder from the Supplementary CD-ROM to your hard disk. Launch Photoshop Elements 3.0. In the Welcome Screen, click on Make Photo Creation.
- (2) The Photoshop Organizer window will open, followed by the Creation Setup dialog box. In the Creation Setup dialog box, select Slide Show and click OK.

3 When you are asked to select a slide show format, choose Custom Slide Show and click OK

4 When the Slide Show Editor appears, click on the Add Photos From Organizer or Folder icon (1) from the shortcuts bar and select Add Photos From Folder

5 When the Choose Your Photo Files dialog box opens, look for the Slide folder, hold down the shift key, and select all the files inside the folder. Click Open.

6 The images will be added to the Slide Show Editor. The timeline at the bottom of the main window displays the order of the slides, as well as the time and transition information for each picture. You can edit your slide show directly from this location.

7 Selecting a thumbnail in the timeline displays the slide in the main window.

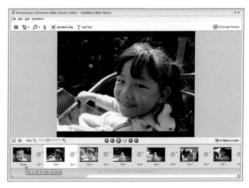

8 The first slide is set to display for 5 seconds in the timeline. This duration is too long. Let's shorten the display time to 3 seconds. Click on the arrow icon ▼ of the first frame and select 3s from the menu.

If you click on the play button in the main window, the slide show will play in the main window and you can see that the duration for the first slide is about right. Let's set all the slides to display for 3 seconds each. Click on the arrow button ▼ of the first slide and select Set all Slides to 3s.

Now let's change the way that a slide changes into the next photo in the show. The or symbol between two slides indicates that there is no transition between the slides. To insert a transition between slide one and two, click on the arrow button between the slides and select **Checker Board**.

(1) As in step 10, set the transition between slides 2 and 3 to **Barn**. When you are done, experiment with other transitions. You can also change the duration of any given transition.

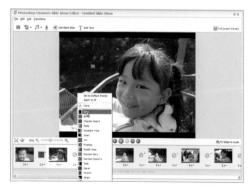

- (12) To add sound to the slide show, click the Add Audio from Organizer or Folder button (11-) from the shortcuts bar and select Add Audio from Organizer.
- Select Add Audio from Folder if you want to use your own audio files.

(14) If you look at the bottom of the Slide Editor window, you can see a blue bar across the timeline. This indicates that an audio file has been added. If you scroll to the right, you can see the audio file's name and also where the music ends.

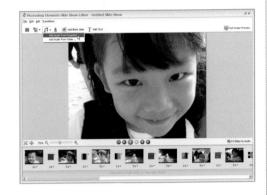

- If an audio file stops before the slide show ends, there are three ways to solve this problem.
- You can click on the (n•) button on the shortcuts bar to select another audio file. This file will start playing after the previous one ends.
- The second way is to click the Fit Slides to Audio icon (** on the lower-right corner of the main window. The duration of the slides will be shortened automatically to fit the music.
- · Another way is to double-click on the blue bar and check the Repeat Music Until Last Slide box,
- 15 Let's insert a title for the slide show. Select the first slide and click on the Add Blank Slide button (@ Add Blank Slide button (on the short-cuts bar.

16 This will insert a blank slide between slides 1 and 2. In the timeline, drag the blank slide over the first slide to place it right at the beginning.

17) In the timeline, double-click on the blank slide to change the slide's color. Choose a color and click OK.

(18) Click on the Add Text button (T Add Text) in the shortcuts bar and enter a title.

(19) Click on the Play button () to preview the slide show.

To save your work, click on the Save the Current Slide Show button (). When the Adobe Photoshop Elements dialog box appears, name the slide show and click the Save button.

21 You can see that the slide show has been saved to the Photo Browser in the Organizer window.

In the Slide Show Editor window, select [File]-[Output as WMV]. In the Adobe Photoshop Elements dialog box, click Change WMV Output Quality to change the output quality, or leave the default (high quality output) unchanged. Click OK.

In the Save As dialog box, select a folder to save the file to and click Save. Don't be surprised if it takes a while to save the file, as your final movie file might be quite large.

After the file is saved, you will see a message asking you if you wish to import the file to your catalog. Click Yes. This will add the file to the Photo Browser.

In the Photo Browser, you can see both the slide show and WMV files you've created. You can double-click on the WMV file to play it.

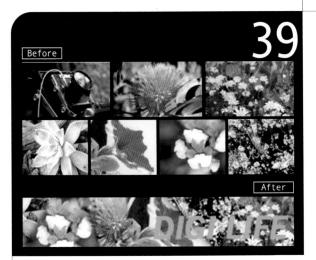

Making a Web Banner

You can use Photoshop Elements to create images that are optimized for the Web, and then use those images as part of a Web site. In this section, you will learn to use the Gradient Map command together with the Photomerge command in making a Web banner.

- Select [File]-[New]-[Photomerge Panorama] from the menu bar. When the Photomerge dialog box appears, click Browse.
- 2 Select the Sample\Chapter 6\banner folder on the supplementary CD. Hold down the Shift key and click each of the pictures in the folder to select all of them. Click Open. This will add the selected pictures to the Photomerge dialog box.

3 Click OK. A warning message saying that Photomerge is unable to merge the images to form a panorama appears. Click OK to close the message box.

When using Photomerge to make a panorama, the source images must overlap between 15% and 40%. Otherwise, Photomerge may not be able to assemble the images. When making a Web banner, the images to be merged may be entirely different, and Photomerge won't be able to automatically align them. In such cases, you'll have to manually arrange the images instead.

(4) In the Photomerge dialog box, drag an image from the lightbox onto the work area, as shown. The overlapping edge between the images is blended automatically.

Repeat step 4 on all the other images on the lightbox. Remember to position them with the edges overlapping, as shown.

To blend edges seamlessly, you need to move the image around until you find the perfect position.

6 Check the Advanced Blending option under Composite Settings on the right of the Photomerge dialog box. Click Preview.

7 Click OK to merge the photos. The panorama will appear in a new window.

8 Select the Crop Tool () from the toolbox. Set Width to 468 pixels, Height to 60 pixels, and Resolution to 72 pixels/inch.

The Crop tool's default unit of measurement for width and height is centimeters. If you type 468, it will be interpreted as 468 cm. To use a different unit of measurement, you need to include the unit as well (i.e., 468 pixels).

9 Select the part of the image to be used as the Web banner. Hit Enter to crop off the unwanted areas.

(10) Select [Layer]-[Duplicate Layer] from the menu bar. When the Duplicate Layer dialog box appears, click OK to make a copy.

(11) Click the Create New Fill Or Adjustment Layer button () in the Layers palette and select Gradient Map. In the Gradient Map dialog box, click on the arrow to open the Gradient Picker and click the [Black, White] square.

Click OK. A black-and-white gradient map is created.

The Gradient Map command takes the tonal range of an image and maps it to the colors of the gradient you choose. In this example, the gradient map is in black and white.

(13) Select the Rectangular Marquee Tool () from the toolbox. Make the selection, as shown here.

(14) Choose [Select]-[Feather] from the menu bar. In the Feather Selection dialog box, set Feather Radius to 100 pixels. Click OK to soften the edges of the selection.

15 Press to remove the gradient map and reveal the color image in the selection. Press Ctrl + D to deselect.

If you do not apply feathering to the selection border, the edges will be distinct without a gradual transition between the colored and black-and-white sections of the image.

[6] Select the Horizontal Type Tool (T) from the toolbox. In the options bar, set Font to **Franklin Gothic Medium** and Size to **40 pt**.

Click the Set The Text Color swatch in the options bar. When the Color Picker dialog box appears, click the Only Web Colors checkbox. This ensures that the Web banner uses only Web-safe colors or colors that will display accurately on computer screens. Set the hexadecimal color value to **99FF00**.

(8) Complete the Web banner by typing in the text as shown.

19 Select [File]-[Save For Web] from the menu bar and save the image as a GIF or JPEG file.

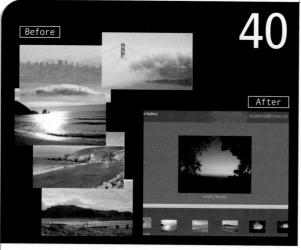

Making a Web Photo Gallery

These days, most professional photographers have a Web photo gallery where they display their pictures on the Internet. A Web photo gallery is a simple site consisting of a home page with thumbnails of images that you can click to see full-sized versions. In Photoshop Elements, creating a Web photo gallery is very simple. You will only need to enter some information and make some selections, and the program will do the rest for you.

1 Click on Photo Brower (Ciliphoto Brower) in the main menu. In the Organizer window, select [File]-[Get Photos]-[From File and Folders] to load the images that will be used in the Web photo gallery.

(2) When the Get Photos from File and Folders window appears, choose all the images in the **Sample\Chapter 6\Web** folder on the supplementary CD and then click the Get Photos button.

3 As we can see here, the selected images will appear as thumbnails in the Organizer window. To create the Web photo gallery, select Create (

4 In the Creation Setup window, select Web Photo Gallery and then click OK.

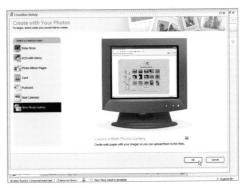

5 In the Adobe Web Photo Gallery window, set the Gallery Style to **Horizontal Neutral**.

6 To choose the destination folder, click on the Browse button next to Destination. In the Make New Folder window, click on Create New Folder to create the folder where the images will be saved.

Enter the name of the photo gallery and your email address. As the Web photo gallery is created, the images and files will be saved automatically to the Site Folder selected under Destination.

Click Save to automatically create the Web photo gallery. A preview screen will appear as shown here.

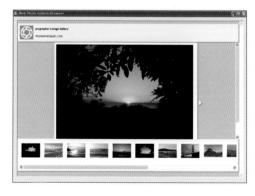

Ouble-click on the automatically created index.html file to see the Web photo gallery in the Web browser. Click on the thumbnails at the bottom to see a larger view of the image.

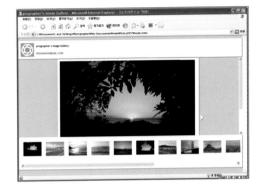

If a file name is very long, it increases the spacing between the images. For a more even spacing, keep the file names short or of consistent lengths.

Contents of the Supplementary CD

Insert the supplementary CD-ROM into your CD-ROM drive. You should see these two folders.

Program Folder

This folder contains a trial version of Photoshop Elements 3.0. Double-click on the **Setup.exe** file in the Photoshop Elements Trial - Win folder to install the trial version of Photoshop Elements 3.0, which can be used for a period of 30 days.

Sample Folder

This folder contains the sample images used in this book, organized by chapters. Each chapter folder contains example files used in the techniques section of the corresponding chapter. The Final folder contains the "After" image for the corresponding exercise.

Index

foreground color, 22

Α	Remove Color command, 57, 60 Replace Color command, 55	Save for Web, 31 Welcome Screen, 17-20
Active image area, 22	Color Replacement tool, 78-81	Distort command, 154-156
Add Noise filter, 182	Color Variations command, 73	Divide Scanned Photos command, 132
Adobe Acrobat, 14	Color Variations dialog box, 73	Dodge tool, 118
Alpha channel, 16	Contrast (correcting), 37-49	Dots per inch (dpi), 12
Artist's color wheel, 73	adjusting with Levels command, 42-44	Dpi (dots per inch), 12
Auto Smart Fix command, 187	adjusting with Shadows/Highlights	
	command, 45-47	E
В	analyzing with Histogram command,	Editor window, 21-23
Background color, 77-86	38-39	active image area, 22
Backlighting, 45-47	brightening a specific spot, 48-49	menu bar, 21
Black-and-white image	Brightness/Contrast command, 40-42	options bar, 22
desaturation, 57-60	Brightness/Contrast dialog box, 40-41	palette bin, 23
removing color, 61-63	Cookie Cutter tool, 91	photo bin, 23, 132
coloring, 64-70	Copying	shortcuts bar, 22
Blending colors, 73	Copy command, 101	status bar, 19
Blending modes	duplicate layer, 59	title bar, 21
Multiply, 175	Layer Via Copy command, 150	toolbox, 22
Overlay, 60, 63, 179	Creation Setup dialog box, 186-200	workspace buttons, 23
Screen, 183	Crop tool, 116-117, 203	Emailing creations, 190-191
Blur (correcting), 40-41		Eraser tool, 111
Brightness/Contrast command, 40-42	D	Exposure (analyzing), 38-39
Brightness/Contrast dialog box, 40-42	Define Pattern command, 182	Eyedropper tool, 55
Brush tool, 94-98	Desaturation, 57-60	
Burn tool, 69- 96-98	Deselect command, 49	F
	Dialog boxes	Feathering, 75
C	Brightness/Contrast, 40-42	Feather Selection dialog box, 49
Camera Raw dialog box, 133-135	Color Variations, 73	Filters
Channel, 14, 16, 39, 44	Feather Selection, 49	Add Noise, 182
Clone Stamp tool, 145-148	Histogram, 38-39	Gaussian Blur, 143
and shift key, 148	Hue/Saturation, 54	Grain, 173
CMYK color model, 73	Levels, 44	Lens Flare, 144
Color, 51-81	Liquify, 99-100	Liquify, 99
background color, 22	Motion Blur, 171	Motion Blur, 171
Color Picker, 82-86	Photomerge Panorama, 168-170	Paint Daubs, 106
color wheel. 73	Replace Color, 55	Photo. 72-73

Save As, 30

Ripple, 151 Selection Brush tool, 57, 94 H Threshold, 62 Movina Hand tool, 33, 100, 117 File Format, 14-16 Hand tool, 33, 100, 117 Handles, 102 BMP format, 15 Healing Brush tool, 86-90 CompuServe GIF format, 14 Histogram command, 38-39 GIF format, 14 Opening files, 24-26 Histogram dialog box, 38-39 JPEG format, 15 Options bar, 22 Hue/Saturation dialog box, 54 PCX format, 16 Organizer window, 27-28, 186 Hue/Saturation command, 52-54, 66-PDF format, 14 date view. 28 67, 174 PDP format, 14 find bar, 27 Photoshop EPS format, 15 main window, 27 PICT format, 16 photo review, 28 PIXAR format, 16 Internet, see web tags and collections panes, 28 PNG format, 15 thumbnail size slider, 28 PXR format, 16 timeline, 27 PSD format, 14, 70, 103 Lasso tool. 48 sort. 28 RAW format, 16, 133 Layers TGA format, 16 blending modes (see blending P TIFF format, 16 modes) Palettes, 23 File size, 11 changing background laver into Panorama (stitching), 168-170, 201-Fill command, 140, 182-183 normal layer, 137 205 Flatten Image command, 103 Create a New Layer button, 59 Paste command, 101 Foreground color, 22, 79 create new fill or adjustment layer. Pattern (see define pattern command) Free Transform command, 102, 138, 72.204 Perspective (altering), 154-156 153 duplicate layer, 118 Photo bin, 23, 132 Layer Via Copy command, 121 Photo Browser button, 186 G opacity, 141 Photo Compare command, 92 Gradients style settings, 153 Photomerge Panorama command, Foreground to Transparent gradient, Levels command, 42-44 168-170, 201-205 Levels dialog box, 44 Photoshop Elements interface Linear gradient, 122 Lighting (see contrast) Editor window, 21-23 Gradient map, 201 Liquify command, 99-100 Organizer window, 27-28 Grayscale mode, 56 Welcome screen, 17-20 M Grid, 155 Picture Package command, 125 Magic Wand tool, 57, 120, 126 Pixels, 10 Menu bar, 21 Pixels per inch (ppi), 11 Move tool, 102, 109 Polygonal Lasso tool, 136 Masking Portrait sizes, 117 adjustment layer, 72 Portraits (enhancing), 83-129

Postcard (making), 186-191 Ppi (pixels per inch), 11 Product pictures, 161 R Raw image file, 133-135 Red Eye Removal tool, 84-85 Reflections (creating), 149-157 Remove Color command, 57, 60 Remove Color Cast command, 86-87 Replace Color command, 55 Resizing canvas size, 137, 149 image, 102 Resolution, 10-13 dpi, 13 file size, 11	Lasso tool, 48 load selection, 65, 114 Magic Wand tool, 57, 120, 126 Polygonal Lasso tool, 136 Rectangular Marquee tool, 139 save selection, 65, 70 Selection Brush tool, 57, 93, 105 Selective focusing, 112-115 Sepia-toned image, 71-72 Shadows/Highlights command, 45-47 Shortcuts bar, 22 Slide show (making), 192-200 Smudge tool, 119 Snow (creating), 181-183 Spot Healing Brush tool, 86-88 Status bar, 22 Studio background (creating), 116-125 Styles and Effects palette, 139	Eraser tool, 111 Eyedropper tool, 55 Hand tool, 33, 100, 117 Healing Brush tool, 86-90 Horizontal Type tool, 152, 154 Lasso tool, 48 Magic Wand tool, 57, 120, 126 Move tool, 102, 109 Polygonal Lasso tool, 136 Rectangular Marquee tool, 139 Red Eye Removal tool, 84-85 Selection Brush tool, 57, 93, 105 Smudge tool, 119 Spot Healing Brush tool, 86-88 Zoom tool, 32-33 Toolbox, 22 Type (see text)
pixels, 10	Blizzard, 183	<u>V</u>
ppi, 11, 13 RGB color mode , 64	Clear Emboss (type), 153	Viewing tools, 32-35
RGB color wheel, 73	Vertical Color Fade, 174	grid, 155
Rotating	Wood Frame, 129	ruler, 154 View actual pixels, 69
Flip Layer Horizontal command, 109	Т	view actual pixels, 00
Flip Layer Vertical command, 138	Text, 152	W
Ruler, 154	adding text to photo, 152	Web, 201-209
S	Horizontal Type tool, 152, 154	web banner, 201-205
	merging text and image, 140	web photo gallery, 206-209
Saving files, 29-31 Save As dialog box, 30	Warp Text command, 152	Welcome screen, 17-20
Save For Web dialog box, 31	Threshold command, 62-63	edit and enhance photos, 19
Selecting	Title bar, 21	make photo creation, 19
add to selection, 75	Tools	product overview, 17
brush size, 65	Brush tool, 94-98	quickly fix photos, 18
contract selection, 115	Burn tool, 69, 96-98 Clone Stamp tool, 145-148	start from scratch, 20 start up in, 20
Deselect command, 49	Color Replacement tool, 78-81	view and organize photos, 18
Elliptical Marquee tool, 162	Cookie Cutter tool, 91	view and organize photos, To
feather, 75	Crop tool, 116-117, 203	Z
hide selection border, 107	Dodge tool, 118	
invert, 121	Elliptical Marquee tool, 162	Zoom tool, 32-33

Acknowledgements

I would like to thank ED, Lasid, and Simona for modeling for the pictures and also thank all the individuals who contributed photographs for this book.

Picture Copyright © 2004 Angelica Lim: pages 21, 86

Picture Copyright © 2004 Brianne Agatep: page 126

Picture Copyright © 2004 Bonnie Bills: page 201

Picture Copyright © 2004 Carl Keyes: pages 48, 181

Picture Copyright © 2004 Ellen Bliss: pages 55, 74

Picture Copyright © 2004 Ji Yong Kim: pages 42, 45, 78, 93, 99, 108, 126, 154, 161, 171, 176, 186

Picture Copyright © 2004 Judy Fong: pages 38, 39, 149, 168, 206, 208, 209

Picture Copyright © 2004 Larry M. Gottschalk: pages 38, 39, 40, 52, 57, 61, 136, 148, 157, 201, 208, 209

Picture Copyright © 2004 Mabel Lee: page 64

Picture Copyright © 2004 Pete Gaughan: pages 152, 173

Picture Copyright © 2004 Sang Hoon Lee: pages 12, 71, 34, 192

Picture Copyright © 2004 Sang Youl Park: page 84

Picture Copyright © 2004 Tracy J. O; Brien: page 201